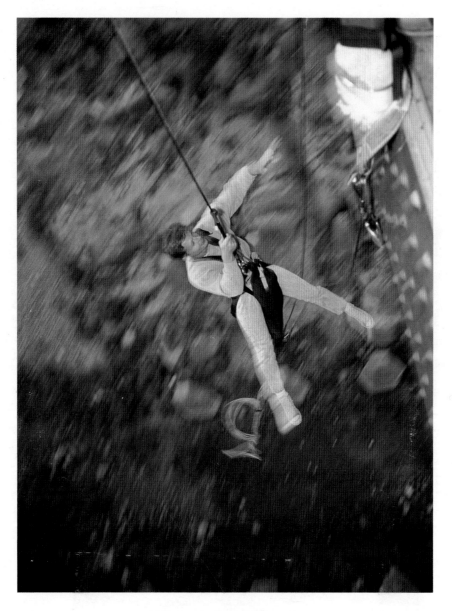

THIS ONE'S FOR
MEL SCOTT

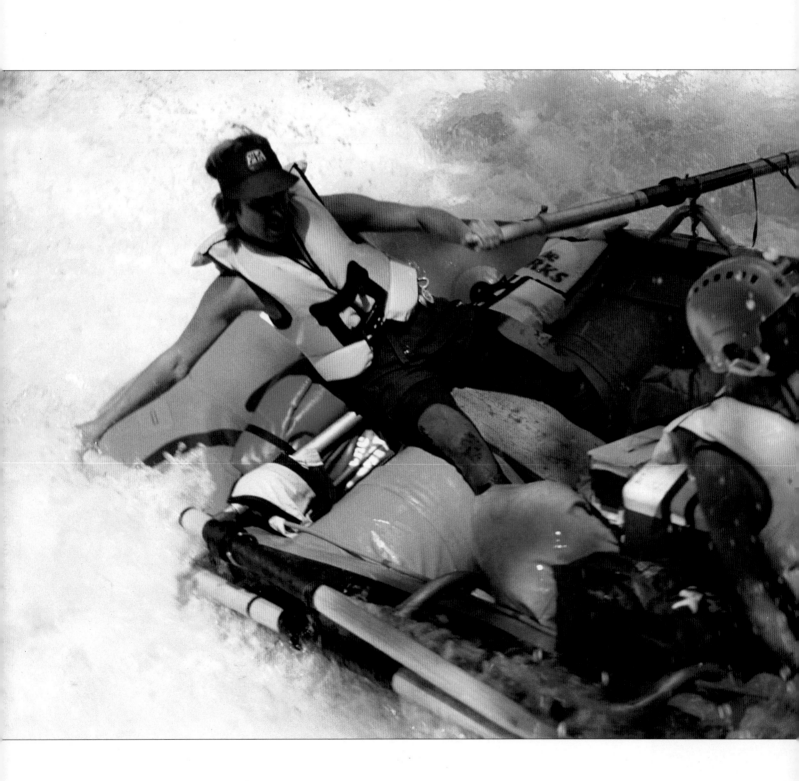

# American & World Geographic Publishing
## Helena, Montana

© 1991 American & World Geographic Publishing, all rights reserved.  Text and photographs © 1991 John Annerino
CIP data is found on page 5.  Printed in Hong Kong.

# HIGH
# RISK
# PHOTOGRAPHY

**text & photographs by**

**John Annerino**

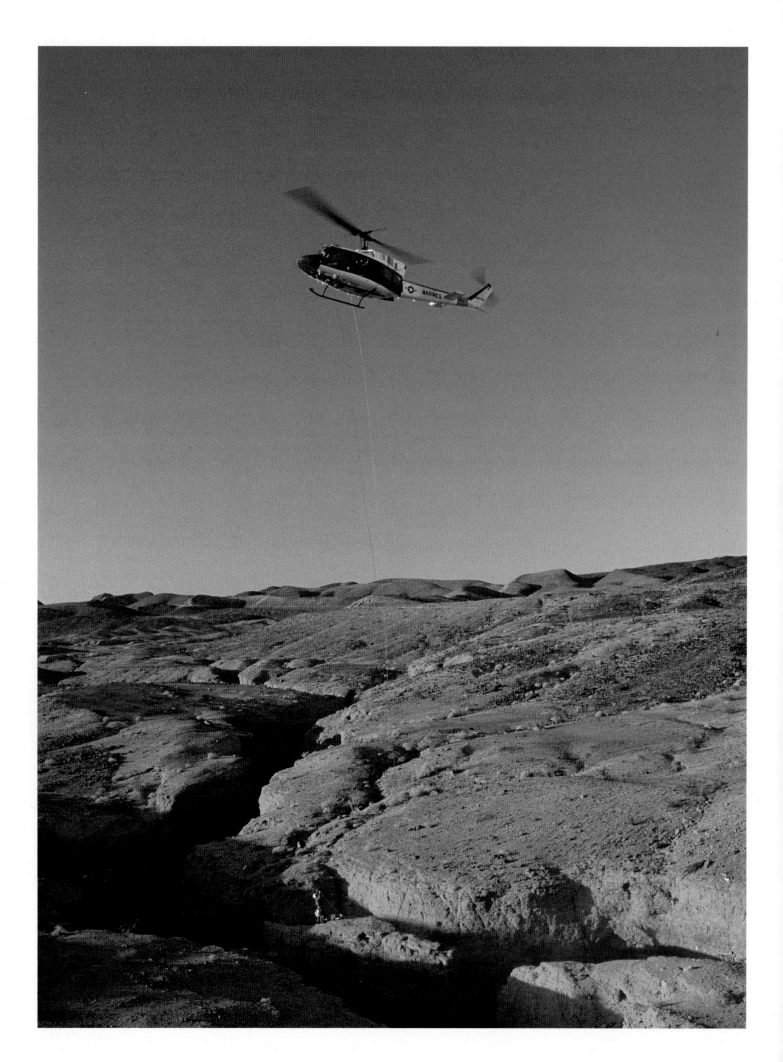

# CONTENTS

**Library of Congress Cataloging-in-Publication Data**

Annerino, John.
High-risk photography : the adventure behind the image / by John Annerino ; foreword by Melvin
L. Scott.
     p.  cm.
   ISBN 0-938314-99-8
    1. Photojournalism.  2. Annerino, John.   I. Title.
TR820.A56 1991
770'.92--dc20
[B]                                91-13260

# FOREWORD

My own abiding love and passion for photography began with an entry-level job with Time Inc. in 1963. This photographic journey has given me the chance to see and work with the world's best photographers...and, sometimes, the worst. It would be impossible to guess at the numbers of photographs I have seen in portfolios, filed in folders for future use in books and edited for publication in *Life* magazine.

Although I have had the great joy of working as a picture editor with photographers who specialize in every conceivable subject, my primary involvement has been with photojournalists. These are the photographers who take pictures simply to give us information, or to tell a story.

I suppose the most interesting subject of any photographer is people, with nature or landscapes coming in second. Look at any amateur or professional photographer's portfolio and you will see a book balanced with nature, landscapes and people, but leaning heavily on the side of people. Pretty girls and children are the front runners.

Photographers are absorbed in people. They take pictures showing us what they are doing or simply how they look. We see them in portraits, involved in sports, in pain, expressing joy, and going about their daily lives.

Most photographers have essentially the same technical skills and most up-to-date equipment, but some simply do not take as good pictures. This, I believe, is due to a difference in style and attitude. This difference helps separate the professionals from the amateurs; when I think of the two qualities, attitude is more important. It makes a photographer really look through the viewfinder for a strong picture. One that will tell a story, have content and composition, set a mood, have energy and style, and capture the importance of the event. In other words, one that gets at the essence of what is happening in front of him. Sometimes, that essence is a matter of wonderful light on a landscape.

Having an all-consuming attitude about photography has helped to launch many photographers on unexpected adventures. These adventures often yield a career of strong and beautiful pictures. Over time some photogra-

phers accumulate enough strong pictures to support book projects.

One such photographer is John Annerino. This is a man who has been photographing for, and has had pictures published in, magazines in the United States and abroad. Namely, *Life, Newsweek, New York Times Magazine, Arizona Highways, Outside, Travel and Leisure, Bunte,* and *Moda,* to list a few. Like many talented, sensitive and creative photojournalists, John Annerino shoots even when not on an assignment. He feels this helps in developing a sharper eye for better pictures, keeping his reflexes on the mark and fine tuning his skills.

Annerino is self-taught, which frees him from the need to follow an instructor's rigid, preset guidelines. He is also a long-distance wilderness runner which has had an impact on his closeness to nature. This exposure to the outdoors enables him to photograph many wonderful and dramatic landscape pictures. Even in placid scenes, Annerino is able to bring drama to the mood of his pictures. Huge boulders with a tiny figure silhouetted against the sky, heavy haze hanging over jagged cliffs, dizzying looks over canyon rims, magic light filling landscapes, or a thrilling ride down a river in a Neoprene raft. Some of the most exciting pictures in Annerino's files are of the many river runs.

Like many photographers who travel around shooting on assignment, Annerino has amassed a very impressive picture file covering a wide variety of subjects. Many of the pictures came from patiently waiting for the right moment, while others came from quick judgment and the ability to recognize what was about to happen. This skill has been invaluable when photographing nature: using his gut reactions when charting the movement of light or shadows in a particular setting. On many occasions this talent came in handy when shooting his book-length rodeo project called *Roughstock: A Behind the Chutes Look at the Toughest Events in Rodeo.* Trying for that dramatic picture of a bucking bronco or bull cannot be directed. Annerino had to simply rely on the element of chance…again using that ability to recognize what was about to happen.

Annerino has taken pictures at every time of day and at every time of year in some of the most dangerous situations and settings imaginable. He documented his most gruelling adventure of running from Mexico to Utah across 750 miles of Arizona wilderness. This photographic odyssey lasted 33 days and took Annerino through a diverse variety of landscapes. Each location offered a different set of photographic problems: mountain peaks covered with snow, rivers and streams, desert areas, meadows, seldom-used trails with aged wooden cabins and even a stretch of interstate highway. This was, without a doubt, one of the most challenging photo-essays that Annerino could have attempted to bring off—especially since he was the subject of his own photography. But the final edit of the pictures showed the skills of a man who was comfortable with his craft. More to the point, the photographs showed a range of spirit and physical endeavor beyond a less knowledgeable photographer.

There have been times when Annerino's fast-moving adventures allowed him to capture some strong and exceptional pictures on film by accident. In most cases, he plans ahead, thus leaving little to chance. His pictures are relatively uncomplicated. They center on the subject at hand, eliminating unnecessary elements that sometimes clutter a picture. Each picture is a single strong statement contained in the frame. Sometimes, energy makes the subject stand out in the picture. In other pictures, the quiet mood captures the viewer's attention. His portraits are warm, straight and sensitive—especially those of women he has photographed.

Although Annerino has photographed everything from social documentary to nature subjects in the Arizona desert, it would be unfair to categorize him in any one area. He brings the same level of pride, enthusiasm, and professionalism to all of his projects and assignments.

For the last three years, Annerino has been working on his most dangerous and perhaps most important picture essay. A set of pictures he simply felt compelled to do. Calling it *Path of Fire: Through America's Killing Ground,* Annerino used his own money and time in hopes of bringing an appalling situation to the attention of people everywhere. The photo-essay documents the plight of Mexican nationals who attempt fifty- to eighty-mile-long midsummer treks across the most deadly desert in North America in hopes of finding work in the United States. This is a project close to Annerino's heart. He has made several harrowing border crossings, each time in hopes of getting stronger pictures, each time exposing himself to the same dangers as the men who were looking for work.

All of this work and effort has taken time, energy, money and a sincere dedication to share his work and help further educate all of us who will stop and look.

—*Melvin L. Scott*

7

# PREFACE

**A**dventure. To many, the very word evokes images of danger, excitement, fear, triumph, the unknown. As a young boy playing in the soot-covered streets of Chicago, adventure to me meant ambushing an eighteen-wheel tractor trailer rig with snow balls and trying to outrun the driver when he got out to chase me. On a more romantic level, I also grew up believing Sir Edmund Hillary and Sherpa Tenzing Norgay's 1953 ascent of 29,028-foot Mt. Everest epitomized all the elements of a classic adventure: distant lands, exotic people, climbing to the summit of the world. Yet, after my father moved our family "out West," I came to realize that adventure wore a thousand beguiling faces—and it no longer revolved around the traditional view of adventure emblazoned in *National Geographic* accounts of Himalayan climbing. It had more to do with the found situations of everyday life; from experience, as well as from the historic adventures I read about concerning frontier Arizona.

Take the forty-niners: Few people beyond the Southwest know that the deadly El Camino del Diablo, "Devil's Highway," claimed the lives of more than 400 prospectors en route to the California goldfields during the 1850s. To those who succeeded in crossing that killing desert, just surviving was all the adventure they bargained for. When I followed the treacherous El Camino del Diablo, it wasn't the personal quest of crossing that desert that lured me, or the riches that at one time lay beyond it; it was photojournalism. I would be drawn to cross that burning wasteland to photograph the brave men from Mexico who follow their modern path of fire in hopes of finding work in the United States. The possibility of photographing—and bringing to light—their life-or-death journey held more meaning to me than my personal adventures, and my lifelong dream of climbing Mt. Everest.

But before I tried crossing the merciless desert Mexicans call El Sahuaro, my life underwent a metamorphosis of sorts. I apprenticed in the deserts and mountains of the Southwest the way no one ever does willingly; I took up photography; and I changed my attitude about life and adventure—at least enough

to accept that my cameras' weight would prevent me from carrying the extra gallon of water that would ensure my crossing El Sahuaro alive.

My journey to reach the starting line for the modern Devil's Highway in the frontier of Sonora, however, was a roundabout one.

Throughout high school, I wanted to be on the other side of the classroom windows. I wanted to know everything about life as I assumed it existed beyond the classroom. But I especially wanted to know more about people: from the new wave of East Coast immigrants I saw mingling with Southwest natives to the migrant farm workers who took me in when I ran away from home. After five high schools, I managed to graduate, as well as survive my overly ambitious wanderings in the deserts and mountains of the Southwest, but I was no more focused about what I wanted to do with my life than when I'd started.

By the time I enrolled in college, acting seemed to quench a young man's curiosity with life. Three of my four years in college were spent studying drama; to support that habit, and my need to continue exploring the outback Southwest, I taught climbing and wilderness survival. Since I was living in a friend's dektol-drenched darkroom at the time, it was only natural that I picked up one of his cameras and started photographing my students as we journeyed through seldom-explored mountains, deserts and canyons.

On graduation I knew I didn't want to be a starving actor any more than I wanted to live paycheck-to-paycheck teaching wilderness survival the rest of my life. I'd already banged out a 600-page autobiography; so I decided to change horses mid-stream and "become a rich writer." Now, up till this point, no one except my dear mother indicated I had any talent for writing whatsoever, but that didn't stop me from hammering out a novel in twelve weeks.

My first shoebox full of rejections amassed, I was beginning to realize the path of a writer was not one I wanted to pursue much further, either. It wasn't the rejections that bothered me—I had confidence. It's just that, as a writer, I suddenly seemed to be trapped in the classroom again—regurgitating an experience when I really wanted to be outside exploring the world and experiencing life. Once I sold a couple of magazine articles, I knew I didn't want to be a writer anymore. In his enthralling retrospective book, *The Photographic Essay,* National Geographic photographer William Albert Allard said it best: "I'd been feeling that my photography wasn't growing, and it takes an awful lot of energy to do both [write and photograph]. It's like trying to tune in on two different frequencies at the same time. A big advantage to being a photographer is that the published work is more likely to be really yours. You can't comitteeize a photograph the way you can a manuscript."

Fortunately, a gifted photographer named Christine Keith showed me a way out of the dungeon I'd written myself into. I'd first met Chris shortly before I fled Phoenix and moved to the small Arizona mountain community of Prescott. Chris's reputation as a photographer preceded her, and since I'd always carried a camera in the wilderness—whether I was teaching, working as a river guide or fighting forest fires—I used it as an excuse to look her up. That meeting turned my head around. Chris's bathroom-turned-darkroom revealed the depth of her ability to capture the essence of people in their daily environments. Hanging, dripping wet, from a spiderweb of thin steel wires were black and white images of people from a world I hadn't known existed: a young girl carrying her month-old sister through the streets of Antigua, Guatemala; a Mao tribeswoman trading opium on the Burmese border of northern Thailand; El Zarco, a Chicano sculptor, firing a Zuniga-influenced bronze in Tepoztlán, Mexico…

Chris brought back soul-stirring images from her travels that demonstrated her willingness to expose a part of herself in order to make a picture that needed no explanations. My own photographic efforts seemed like footnotes in comparison. My exposure to Chris's body of work would leave a lasting imprint and change the course of my life: from that of a camera-starved actor laboring on the novel he dreamed of starring in, to that of an aspiring photojournalist who, like Chris, wanted to capture the people, places and events that shape our lives and the world in which we live.

I got a couple breaks that probably had more to do with persistence—and serendipity—than any photographic talent I might have demonstrated at the time. Not long after I'd completed an unprecedented, 250-mile, eight-day wilderness run below the North Rim of the Grand Canyon, Chris received the disheartening news that her photo essay of the adventure had been rejected by *Life.* They'd generously furnished her with film and processing in exchange for a "first look" at her pictures, so the news was especially difficult for her to take. Their primary reason: she didn't have a picture of my near-drowning while swimming the frigid Colorado River, which they felt was the climax of the story.

Chris made heroic efforts to trek into remote corners of the Grand Canyon at five different points in order to photograph the adventure beginning-to-end and, understandably, she couldn't be everywhere at once.

Chris received her photo essay back on Friday. I felt so strongly about her photo essay that I decided to tell the editor at *Life* in person. I braced myself with a shot of tequila and boarded the redeye to New York Sunday night. I didn't know Mel Scott from Adam, but I would be waiting at his office first thing Monday morning.

Weary-eyed from the all-night flight, I straggled into the Time, Inc. building and told security I had an appointment with Mr. Scott, which I did not. When they phoned his office, I feared I'd be banished from Rockefeller Center—end of story. To my surprise, however, Mel apparently cleared me through security, and suddenly I found myself rocketing toward the thirty-first floor.

When I walked into the picture department, I think Mel was as surprised as I was, and he later told me that in all his years at Time, Inc. he'd never had a photographer come across country unannounced to repitch a story that had already been killed. I stated my case sim-

9

ply—the editors made a mistake about Chris's essay: it was powerful; this kind of end-to-end Canyon run had never been done before; and the near-drowning could be dealt with in the text. Mel listened to me patiently, then led me into the projection room where he instructed me to re-edit the story the way I saw it; he would look at the new edit as soon as he finished meeting with Harry Benson and Co Rentmeister, two contemporary *Life* photographers I greatly admired.

Now shaking to be on such hallowed ground, I waited an hour before Mel could go through the pictures. Once he reviewed them, he agreed to show my edit to the editors. Three hours later I was on a plane to Phoenix, confident Chris's photo essay would be published.

The story was turned down again, and I still didn't agree with the editors, but after walking through the Picture Department of *Life,* I knew what my calling was.

In the ensuing two years, I pestered Mel with freelance picture essays I'd shot on everything from white water rafting to riding Brahma bulls to dangerous helicopter and rock climbing commercials. He always encouraged me, sometimes telling me, "The next one may be it!" But still I couldn't get a picture published in *Life* to save my own.

I kept shooting for regional magazines and working on freelance picture stories, but I was growing discouraged living hand to mouth. I was about to throw in the towel when I received a contract from *Arizona Highways* magazine to photograph a book on Arizona's back country. The train had finally come in, not with *Life* yet, but with one of the premier showcases for landscape photographers. Here was a year-long project I could sink my teeth into. I would be paid to explore and photograph the mountains, canyons, and deserts of Arizona, and the only hitch was that, at some point, I would have to lock myself in a room and write the text as well.

It was spring in the desert. The golden poppies were in bloom. And I was wandering around Organ Pipe Cactus National Monument near the U.S./Mexico border—having

just returned from photographing the rugged summit crest of the Sierra del Ajo. Somehow, a park ranger found me driving one of the remote border roads and handed me a note: "Mel Scott from *Life* Magazine called. He has an assignment for you. Call him immediately!"

I sped to the nearest pay phone and called Mel. He told me *Life* was sending a half-dozen photographers across the country to cover a story on high school proms, and my assignment was to photograph the Taos High School prom in northern New Mexico. "Can you be in Taos tonight?" he asked. "Sure, no problem," I said, not knowing where I was going to get the plane fare or how I was going to get there on time. Then Mel added the caveat, "If you do well on this assignment, it'll be the first of many; if you don't, well, you had your shot." I was about to hang up when he said, "John, take one good picture, and I'll find it!" He'd obviously put himself on the line to give me my first break.

I ran back to my truck and drove like a fiend three hundred miles to Prescott, then another hundred miles back to Phoenix in hopes of catching the last plane to Santa Fe that night.

I made the plane. *Life* reporter Naomi Cutner and I dogged the story around the clock; and several of my pictures ran in "Prom Night, U.S.A.," including one as the full-page opener. (See page 51).

As elated as I was, though, for months afterward I couldn't figure out why my first *Life* assignment was a story about proms when the only picture stories of mine Mel had seen had to do with adventure. Still puzzled, I finally called him to ask. "John," he said, "I first looked at your work for content, and to see what kind of eye you had." Then he added, "If you're going to be a successful photojournalist, you've got to master light and you've got to be able to shoot everything equally well."

I soon discovered that was especially true for photographers like myself, based in the Southwest, trying to make it in magazine photojournalism. Stuck somewhere between Hollywood and Manhattan at the time—light years from Paris, the epicenter for photojournalists covering the world's hot spots—I didn't

have the opportunity to specialize in, say, glamour photography like California-based Herb Ritts, celebrity portrait photography like New York-based Annie Leibowitz, or war photography like globe-trotting James Nachtwey.

Yet, up until that first *Life* assignment, I'd considered myself an "adventure photographer." Fortunately, Mel saw something in my work not even I recognized at the time, and he took me under his wing and pushed beyond my parochial limits until the day he retired as *Life's* Deputy Picture Editor. Although I was disheartened that the person who guided my career so carefully was leaving *Life,* I considered myself privileged he'd helped me develop the skills I needed to grow—and survive—as a photographer. That's when I knew I could cross the sun-scorched Arizona desert with migrant farm workers and photograph their desperate midsummer treks, not as an adventurer but as a photojournalist.

In *La Frontera: The United States Border with Mexico,* author Alan Weisman observed that "despite the Rio Grande's jointly shared status, Mexicans never run the river—they ride or walk alongside it. Americans recreate by devising rigorous tasks like scaling mountains or defying turbulent streams. Residents of the Third World don't need to invent struggles."

...as I was soon to learn. The Mexicans who still struggle across the deadliest desert in North America do what few modern athletes and adventure travelers could endure, and the fact that many survive their life-or-death adventure—which has claimed the lives of hundreds of their countrymen—has little to do with our traditional concept of the word adventure. Yet, this book is a collection of photographs about both—and all the shades of adventure I've photographed in between those two extremes.

While the setting for the book is undeniably the West, including parts of Mexico, many of the photographs were taken on assignment for international picture agencies and national magazines. Some of the other photos, though, were taken in pursuit of my own quest to define adventure and the photo essay; still others, I simply felt compelled to take.

What you will get from this collection of photographs, though, is not technical information about equipment and F-stops, but rather the stories behind the pictures and, I hope, a new way to look at your own world of adventure—however you define the word, and wherever those adventures ultimately may lead you.

—*John Annerino*

# MAGIC LIGHT

## SILHOUETTE IN STONE

▶

*Once known as the Sierra de La Spuma, "Mountains of Foam," for their rugged terrain, the Superstition Mountains have swallowed 51 people alive; many came looking for the legendary Lost Dutchman's Gold—most perished under mysterious circumstances. All began their search in or around Weaver's Needle, a withered finger of volcanic rock scratching the heavens at 4,553 feet.*

*Over the years I've climbed the Needle forty or fifty times, mainly because my students relished the challenge of climbing this sinister Arizona landmark—and returning to tell all who would listen. To reach the base of Weaver's Needle, though, you have to hike through Peralta Canyon, a haunted abyss choked with towering stone monuments once thought to resemble the ancestral spirits of Pima Indians who sought refuge in the range from hostile Apaches.*

*En route to my last climb of Weaver's Needle, I wanted to make a picture of this brooding chasm that captured the spirit and foreboding nature of it. And I thought the strongest possibility was to frame this climber with boulders and expose for the highlights outlined by the direct backlight from the afternoon sun.*

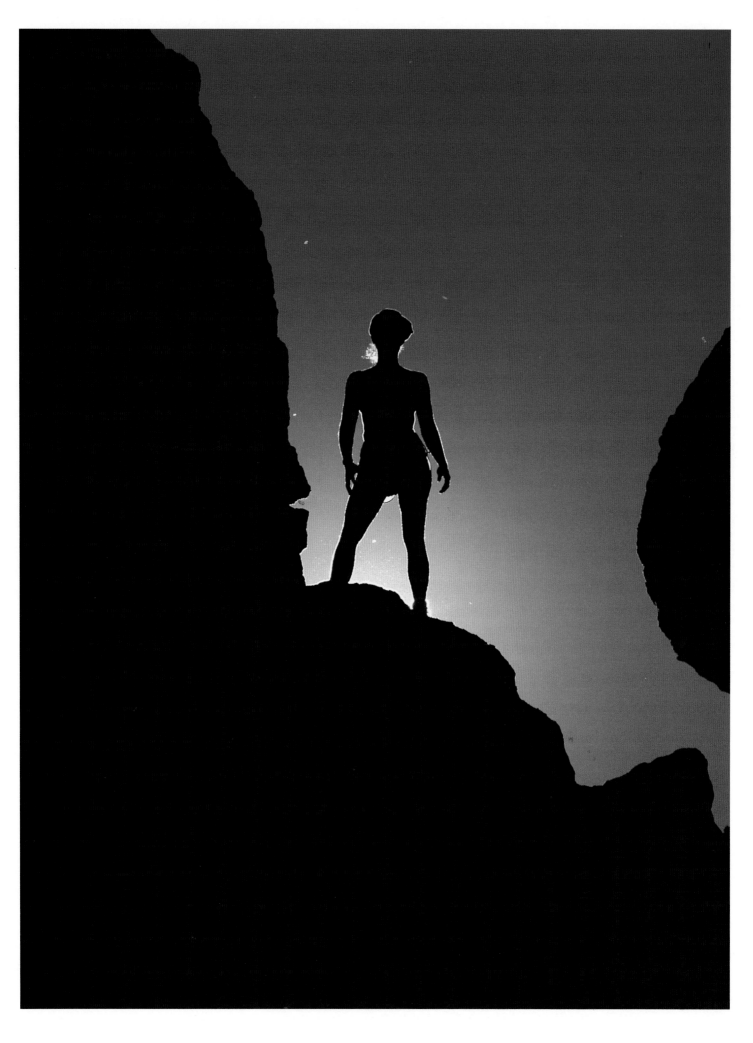

## BILL BROYLES, SIERRA DEL PINACATE

▼

Mexico's 4,235-foot Sierra del Pinacate erupts out of the largest and highest sand sea in North America, the 3,000-square-mile El Gran Desierto. Like much of the Arizona desert that flanks this region of frontier Sonora to the north, this hard desert is a vast and waterless one, devoid of people; it's what early Spanish explorers called a *despoblado*, "uninhabited land," and what author William K. Hartmann recently wrote was "the Sonoran desert's sav-age core." Historically, what little water sustained life in this ancient land was generally found in *tinajas*, or rock basins that oftentimes hold sparse rains for months on end. During drought years, a handful of these tinajas kept alive the Sand Papago, a small band of nomadic people who eked out a hardscrabble existence before marching into ecological oblivion.

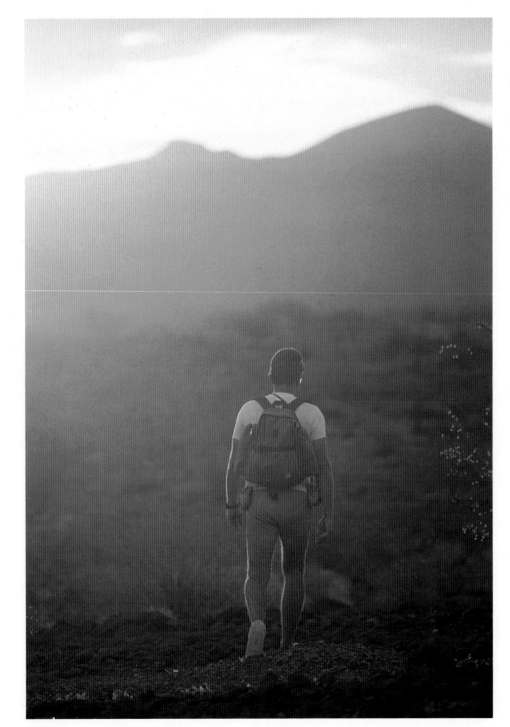

Historian, writer and adventurer Bill Broyles knows this modern despoblado better than anyone, and when he's not criss-crossing it on foot he periodically monitors water levels at its remote tinajas "to study the correlation of rainfall and surface water." But even Bill is the first to admit that's just another excuse he uses to keep exploring the region. Needless to say, his passion for this desert was contagious; I wanted to go into that desert with him immediately! But Bill waited until the mercury was throbbing between 118 and 120 degrees before he invited me on one of his "rain gauge checks." I soon discovered the phrase was a misnomer. In reality, it's a Paris-to-Dakar–type driveathon between tinajas scattered across this black desert like hidden gemstones. That's the easy part; when you can drive no farther in the skull-numbing heat, you have to get out and walk the rest of the way into each of those bee-infested waterholes—usually in the noonday sun.

Before my film melted, I wanted to take a picture that showed what it's like for modern man to walk into that aboriginal desert core, not knowing if he'd find water at the next tinaja, or whether his bones would be picked apart by ravens and turkey vultures. So I photographed Bill from behind, using early morning sidelight to heighten the sensation of heat.

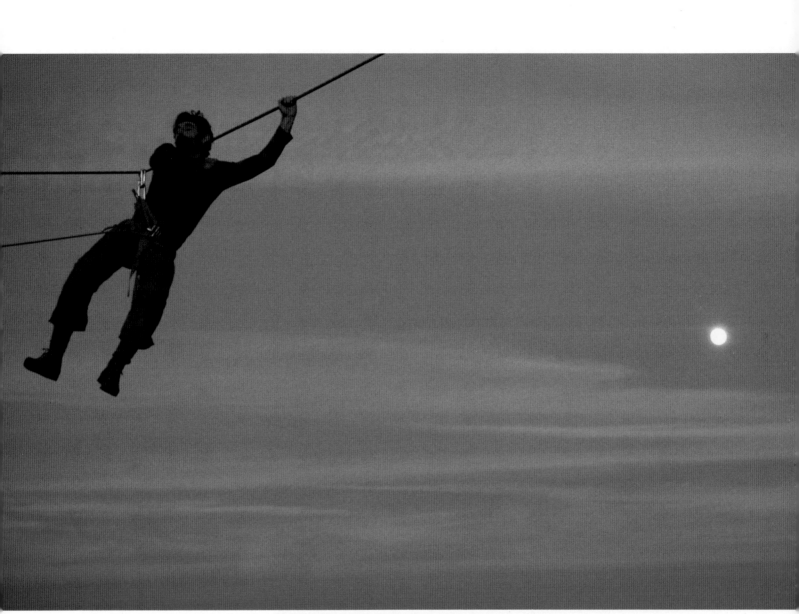

## MOONDANCER

▲

In the golden age of European climbing, a tyrolean traverse was used by climbers to get from one rock pinnacle to the next; ostensibly, the lead climber tied a heavy weight like a piton hammer on the end of his rope and heaved it toward the opposite summit in hopes of lodging it in a crack. He then tested the anchor by going across the ropes first, before safeguarding the rest of the party across.

When I was first trying to break into magazine photography, I shot a freelance picture story on tyrolean traverses; I submitted it to the Black Star agency in hope they would represent the story around the world. The story piqued the interest of agency director Howard Chapnick and, if my memory serves me correctly, he suggested I go back and shoot a strong opening photo. I waited a couple of weeks for a full moon, went back to Pinnacle Peak and, after climbing it with Dave Ganci, fixed my climbing ropes between its twin summits. I'd already sketched out the kind of photo I wanted, but my equipment at the time consisted of one 35mm body and two lenses; I still couldn't afford a flash to fill in the picture and, had I owned a tripod, the ledge I was perched on was too narrow to use it. I obviously couldn't orchestrate the light; so the only time I'd have enough light to take this picture, and show the moon, was at twilight. The hardest part, though, was coaxing my shivering friend to hang out on the rope until the moon finally came up—while I tried to keep my own chattering teeth from jarring my slow handheld exposures.

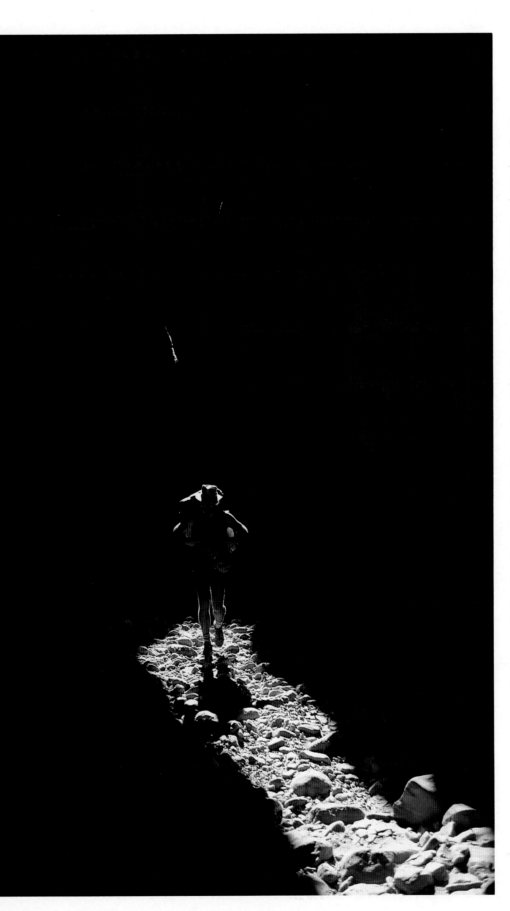

## EARTH CRACK

◄

Twelve miles long, and frequently no more than 15 feet wide, Utah's Buckskin Gulch is one of the longest, narrowest canyons known. As such, this subterranean fissure acts as a natural storm drain during summer monsoons, when deadly flash floods roar through it and jam logs between its walls, 50 feet overhead. Because of this imminent flash flood danger, the safest (as well as warmest) time to explore Buckskin Gulch is during the pre- and post-monsoon weather of early summer and fall.

Under cloudless environmental conditions, though, midday light in the Southwest is totally washed out during those months; so landscape photographers, especially, come to rely on "magic hour" as being immediately before and after sunrise and sunset. That's above ground. In an "incised meander" like Buckskin Gulch, the only time you can take a picture with natural light and slow film speeds is during midday, when vertical shafts of light penetrate the depths of this sandstone defile.

As a photojournalist, I try to avoid setups, or "directing a picture," even in predictable situations. To do so in this case, I had to run ahead of my companion and periodically glance over my shoulder for what looked like the best composition. When I saw what I liked, I waited out of sight in order to ambush Richard Nebeker as he walked through this terrestrial beam of light.

## SERI FISHERMEN

▼

At one time, Mexico's Seri Indians were thought to be the most primitive people in North America—cannibals, some early explorers claimed, with no basis in fact. These same explorers called this sere coastal land *desierto purgatorio,* "desert purgatory." But what was purgatory to outsiders was home to almost 4,000 Seri Indians; they fished the warm waters of the Gulf of California to the west, and hunted and gathered along the cac-tus-studded *bajadas* (alluvial fans) and mountains to the east. Today, their population is only a fraction of what it once was, but the hardy Seri continue to endure on a marginal slip of Sonoran desert most non-Indians still consider purgatory, because the Seri—*Comcáac,* the people—continue to harvest the fruits of both the desert and the sea.

In historic times, brave Seri fishermen plied the Canal de Infierno, "Channel of Hell," off the coast of Sonora in fragile *balsas* (rafts made from carrizo cane), hunting great leatherback and green turtles with flimsy harpoons. With the advent of commercial fishing, though, the balsa—and all turtles—are all but memories to a few Seri elders; the ancient craft has been replaced by a modern fiberglass boat called a *panga.*

Watching these Seri fishermen pole the shallow gulf waters at twilight, I wanted to take a picture that captured the feeling of what it might have been like for the Seri to prowl the gulf before the outboard motor replaced their silent double-bladed paddles.

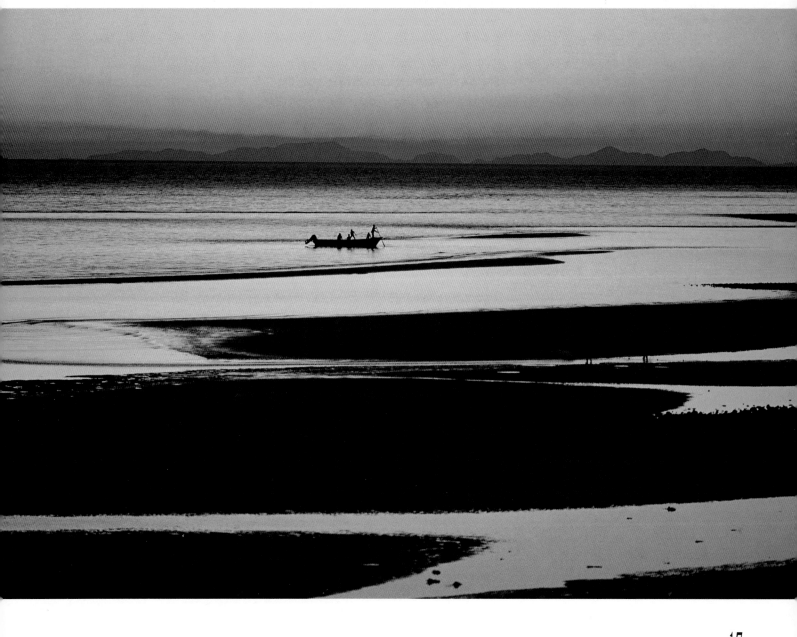

## SACRED MOUNTAIN

▼

Indian tribes as diverse as the Hopi, Navajo and Havasupai revere the San Francisco Mountains as sacred: to the Hopi, they are Nuva-teekia-ovi, "The Place of Snow on the Very Top"; to the Navajo, Dok'o'sliid, "the Sacred Mountain of the West"; and to the only permanent residents of the Grand Canyon, the Havasupai, Huchhassahpatch, "Big Rock Mountain." At 12,633 feet, the San Francisco Mountains are also the highest range in Arizona, consequently, the state's most desireable "high altitude" climb.

As with Weaver's Needle, I visited the San Francisco Mountains extensively throughout my 10-year career as a wilderness instructor. In December of 1974 I led a large group of Prescott College students to the "peaks" in hopes of introducing them to the rigors of winter mountaineering. From that standpoint, the peaks did not let us down. We slogged through thigh-deep snow throughout a long, cold afternoon and, just before nightfall, managed to pitch our tents in a notch on the summit ridge at 11,800 feet—before the wind started howling. The wind blew all night, and tore at our tents, but I promised our group if the weather broke we'd go for the summit the next morning.

The weather didn't break and, to the protests of several students overcome with summit fever, I told everyone we were bailing off the mountain rather than risk frostbite or hypothermia. During our wind-battered retreat, the clouds parted momentarily, and I was able to shoot only three frames before my fingers got numb and the clouds lay down on us for good. Of the three photos, I liked this one best and, as it turned out, it was one of my first published color photographs.

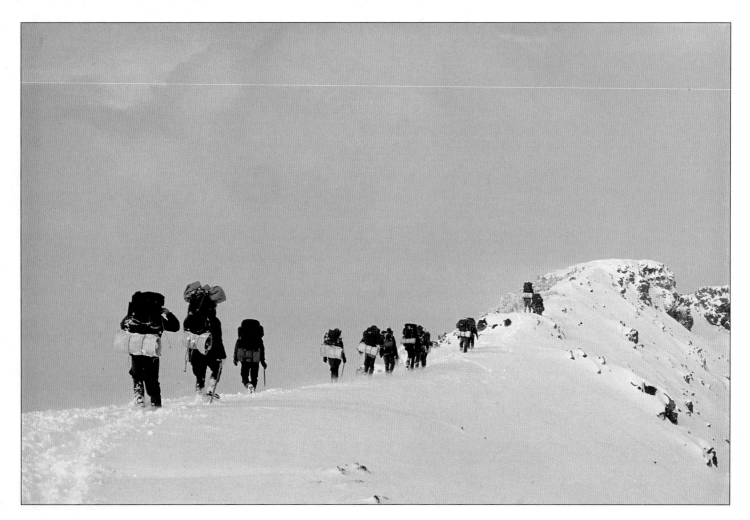

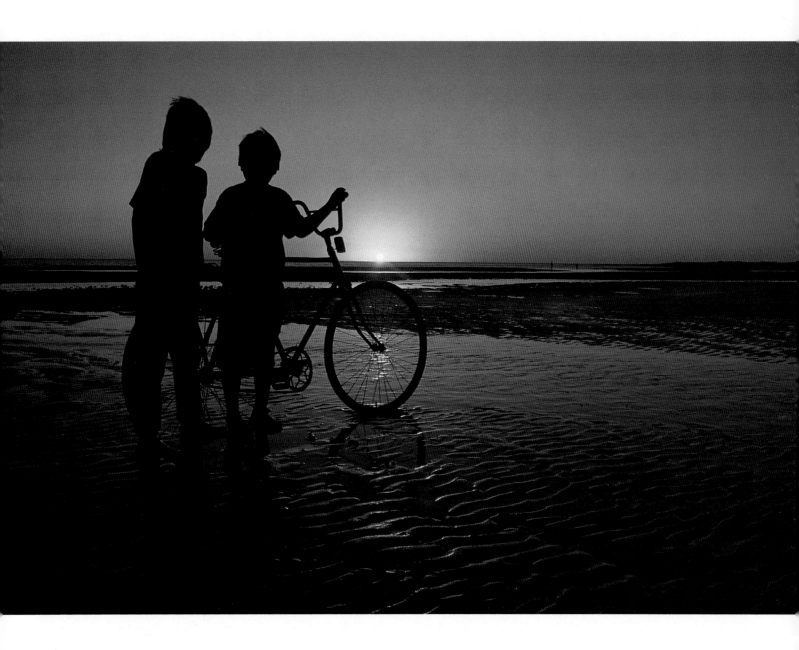

## BICYCLE BOYS

▲

Children and bicycles are inseparable; that especially held true for these two Seri Indian boys who came down to water's edge to watch the sun set over the Gulf of California and Midriff Islands. The bicycle and gulf seemed so incongruous together—yet, that's what made me take the picture.

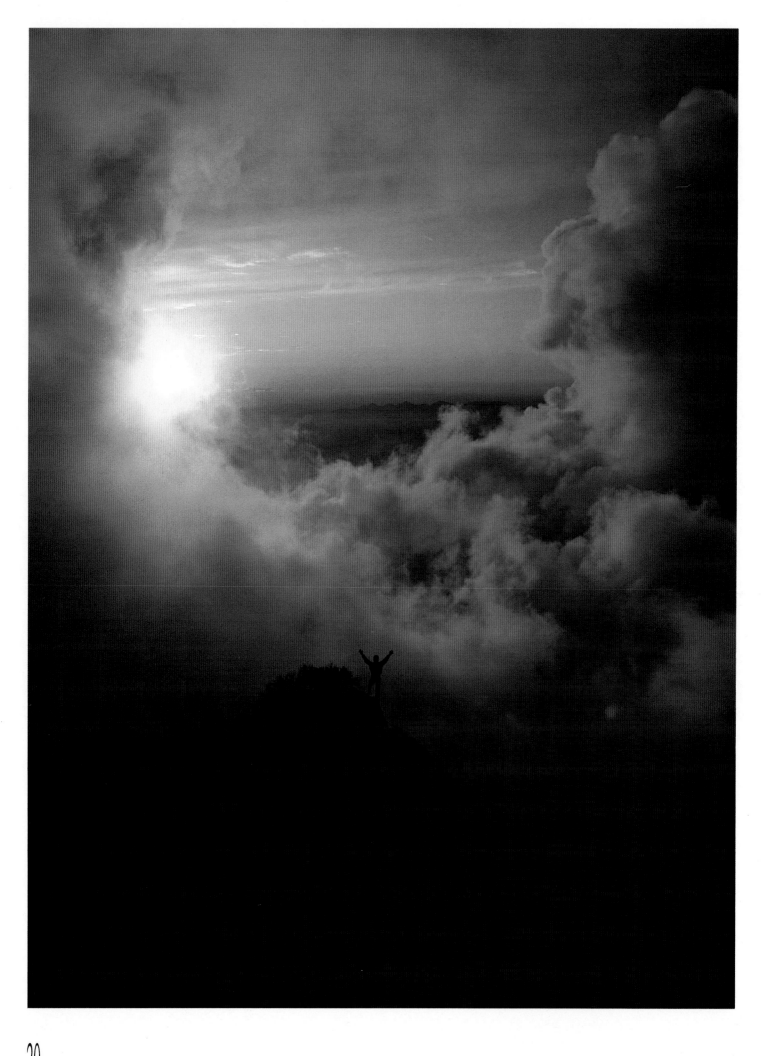

magic light

## BURNING DAYLIGHT

◄

I'd proposed a story to *Arizona Highways* magazine about "classic summits": those mountains or pinnacles climbed in historic times, which required some rock climbing skills to reach the top. Faced with 193 Arizona mountain ranges to choose from, and countless pinnacles, I pared my list down to a half-dozen most photographically and historically interesting candidates. As diverse and spectacular a selection as it was, though, midway into that month-long assignment I was beginning to worry that the look of the climbing photography was too similar. Backdropped by nothing but blue skies, it was.

Fortunately, during the climb of 7,657-foot Browns Peak, an early winter storm broke over the Mazatzal Mountains. Randy Mulkey and I were just descending from the craggy summit when we were suddenly enveloped in an ethereal orange mist. I saw a cover possibility, and asked Randy to scramble down the ridge toward the sun. He didn't hesitate. When he reached our agreed-upon mark, the clouds parted just enough to unveil a blue sky and the distant McDowell Mountains. Randy held up his arms in triumph. Once in a great while, the gods smile and hand you a gift; this was mine. It made the cover.

## BABOQUIVARI PEAK

►

When 7,734-foot Baboquivari Peak was reportedly first climbed by Jesús Montoya and Dr. R.H. Forbes in 1889, Forbes built a signal fire so big it could be seen in Altar, Sonora, a hundred miles south. By then, the people of Sonora had seen their share of fireworks—and had had their fill of gringos.

Justifiably short-fused when much of their homeland was sold to the United States under the Gadsden Purchase of 1853, the Sonorans of nearby Caborca annihilated the 90-man Crabbe's Filibustering Expedition, and went so far as to keep the head of Capt. H.A. Crabbe in an earthenware pickle jar as a reminder to future land pirates.

Since those days, smuggling routes out of the Sonoran frontier have proliferated, often paralleling the length of the Baboquivari Mountains; even to this day, heavily-armed *contrabandistas* still elude posses of law enforcement officers on the steep flanks of this rugged border range. Nonetheless, smugglers have not stopped Baboquivari Peak from becoming what one writer described as the "Matterhorn of Arizona." Even Supreme Court Justice William O. Douglas was beckoned to climb the peak's 1,000-foot-high granite dome in 1951.

Having climbed and photographed Baboquivari Peak by several different routes, I often wondered what it might have looked like when the Sonorans "thought the peak had suddenly erupted" as they watched Forbes' bonfire. I was camped with some friends below the west face of Baboquivari Peak one Thanksgiving day when I finally got my chance to see and photograph what looked like a spiraling cloud of lenticular smoke, trailing the sun behind it. To me, it did, indeed, look like the mountain had suddenly erupted.

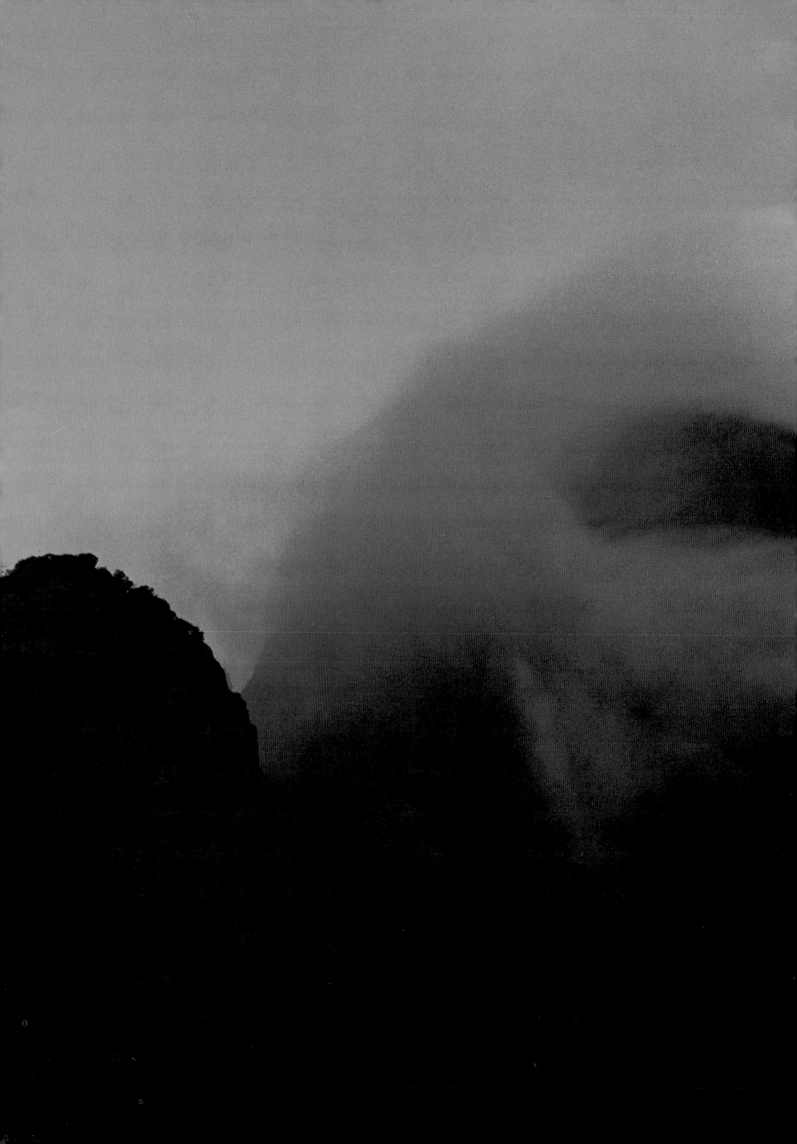

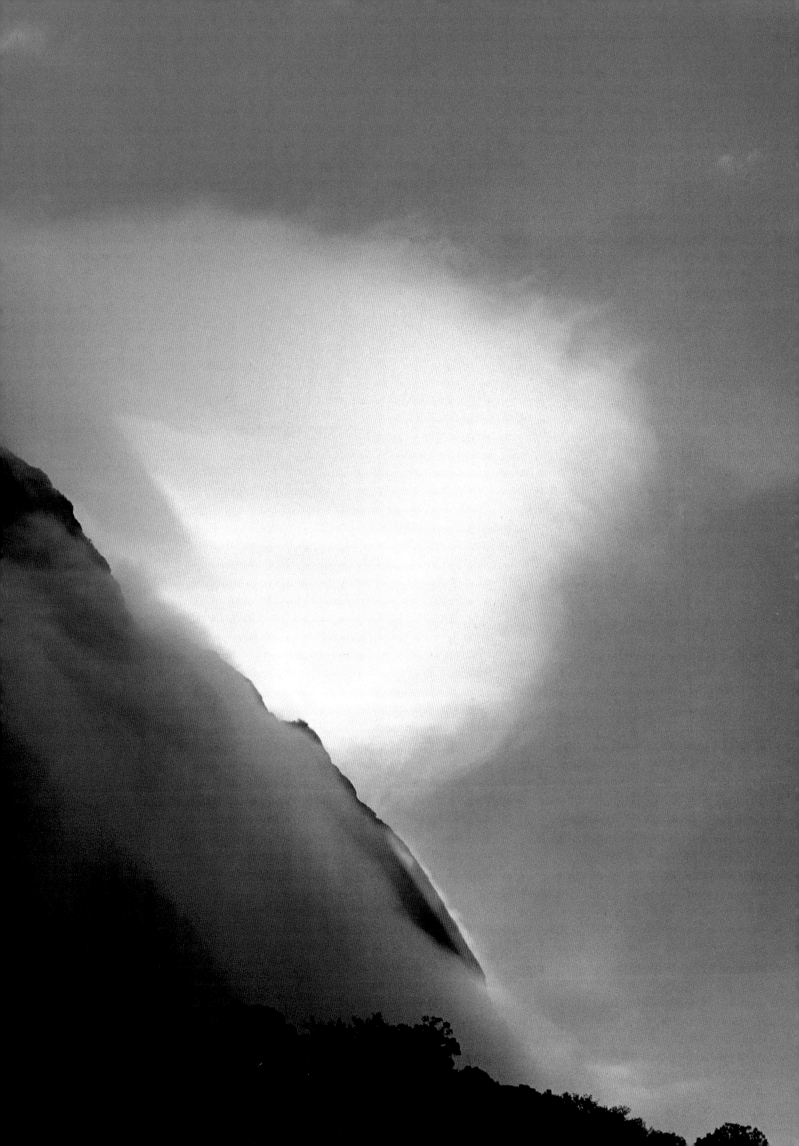

# ACTION

## RUNNING WILD

▶

*When Spanish missionary Fray Francisco Garces explored the Southwest in 1776, much of his route followed a great Indian trade route that wound east from the Pacific Ocean across the stark Mojave Desert, along the edge of the Grand Canyon, to link up with the Zuni Pueblos. Along this desolate 1,100-mile-long track, Garces discovered, Indians including the Mojave, Hualapai, Havasupai and Hopi traveled to distant villages to trade sea shells, desert bighorn sheep skins, woven goods, pottery and other easily transportable goods. Some tribes acted as middle men for one another, and Indians like the Mojave reportedly ran up to a hundred miles a day, as much to explore new country as to trade.*

*What was it like to follow a leg of that ancient path today? Could the land still be seen while running as the Native Americans had first seen it? I wanted to find out. I especially wanted to know what the legendary Hopi runners did when their leg of the trade route atop the South Rim of the Grand Canyon was buried under a half dozen feet of*

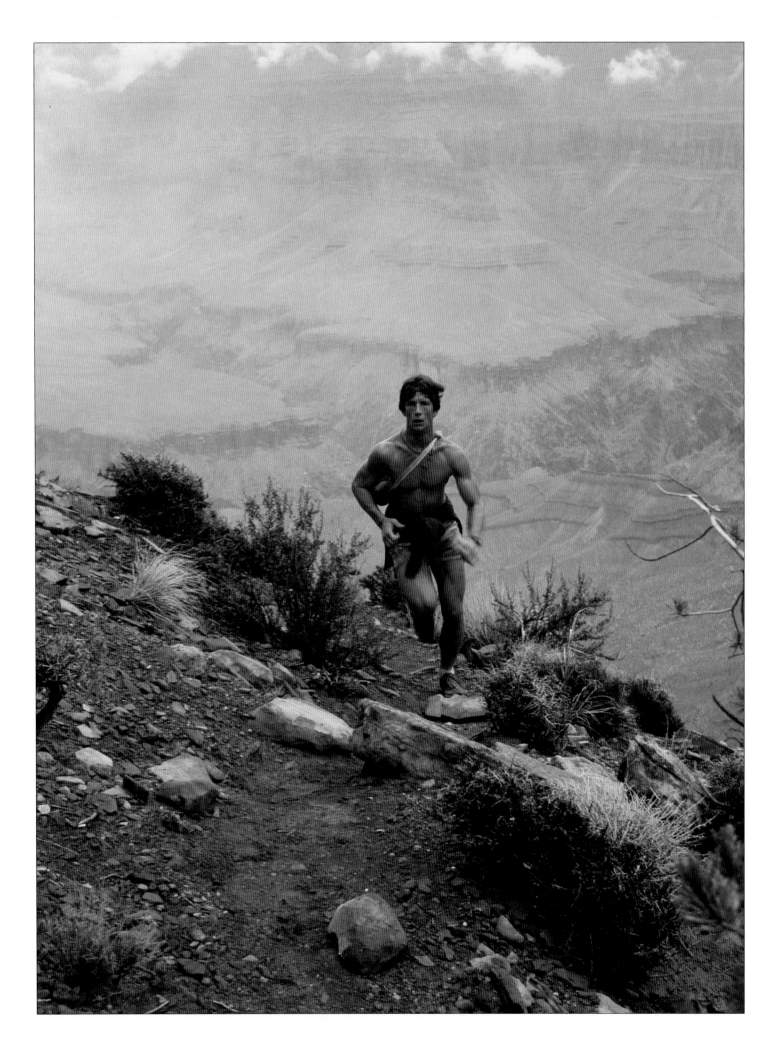

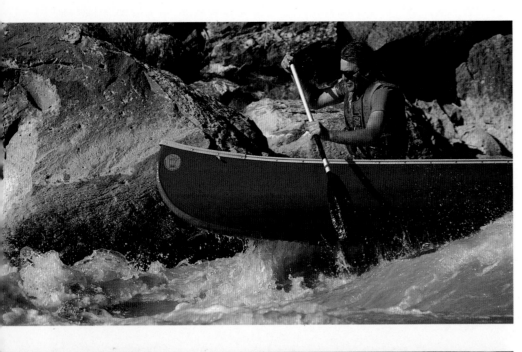

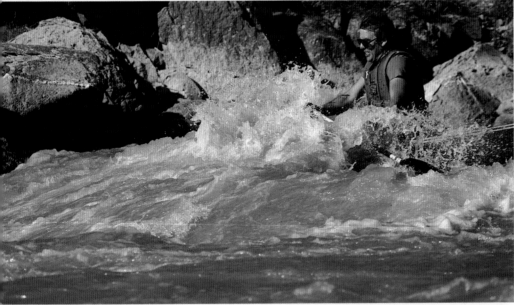

snow? Did they use a warmer inner-canyon pathway to reach the Indian village of Havasupai on the west end of the Grand Canyon? Was it even possible for ancient man to run through the length of the Grand Canyon?

In the spring of 1980, I set out to answer those questions by embarking on an unprecedented 170-mile run below the South Rim. In order to prepare for that week-long adventure, I spent a year training: running upwards of 300 miles a month, including a series of long wilderness runs throughout the Southwest. Of those, my favorite run was along the Boucher Trail in the Grand Canyon, a historic miner's trail that for several miles skirts the very rim of a deadly drop.

I knew the picture possibilities would be striking, so I was especially interested in photographing that run. But running with a camera presented its own set of problems: the camera needed to be readily accessible, so I simply had to hang it from my shoulder and hold the body in my shooting hand as I ran. But the difficult and dangerous part came when I tried to pass my companion on this narrow trail in order to photograph him. I didn't want to direct the picture or set it up. My only solution was to wait until the trail widened enough for me to sprint far enough ahead to precompose the picture and ambush him as he ran through the frame.

## BURIED ALIVE

◀

I was on assignment in Big Bend National Park, Texas, photographing a *Life* story on an Outward Bound course for Fortune 500-type executives; it was a week-long assignment, so I thought there'd be plenty of time to shoot the different kinds of photos I needed. Since the course was primarily a canoe expedition down the Rio Grande, with some rock climbing thrown in to keep the pucker factor going, I was especially concerned with shooting an action sequence that showed the drama of white water canoeing.

I soon discovered the problem with photographing canoeists is that the subjects' faces were oftentimes covered by their paddle handles. The second day down the Rio Grande, we were headed toward the first series of challenging rapids; up to that point, virtually everyone had already capsized in small riffles. So the instructors had us paddle ashore above the rapid to watch them negotiate it. Watching them paddle through like Seminole Indians, I realized the only way to get around the problem of the paddle handles and still get the dramatic sequence I wanted was to time the paddlers' strokes and to study how the canoe responded to the hydraulics of the rapid. Several canoe runs later, I'd figured out the hydraulics and the average number of paddle strokes it took to get through the rapid in order to take this sequence of Rodney Woods in action.

## SUMMER CAMP

▼

Rudyard Kipling wrote in "The Explorer":
Something hidden, go
and find it.
Go and look behind the
ranges—
Something lost behind
the Ranges,
Lost and waiting for
you. Go!
Since the 1940s, many Americans searching for that sense of adventure began their search as youngsters at summer camp. A place of dreams and adventure, far beyond the reach of mom's apron strings.

I proposed a photo essay to *Arizona Highways* magazine called "Summer Camp: An American Tradition." Rather than focus on one camp, I suggested I photograph different kinds of summer camps to see how the pictures played off one another. We drew up a tentative list that included an inner-city camp, a church camp, a camp for children with cancer, a traditional summer camp, and a camp for physically and mentally impaired adults.

Most assignments open my eyes; this one was no different. Halfway into this two-month assignment, I went to the adult camp in northern Arizona, and was immediately taken by this older camper trying to hit a wiffleball sitting atop a plastic pole. She was growing discouraged because she kept striking out. But her counselor patiently encouraged her until she finally hit the ball; when she did, that sense of wonder and joy was expressed in their embrace.

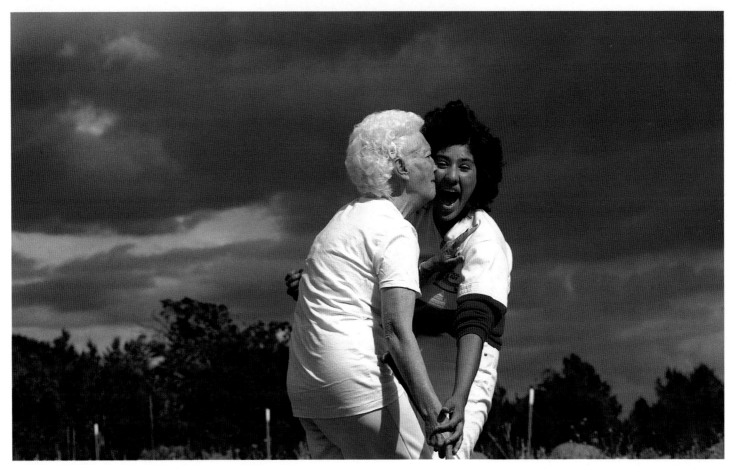

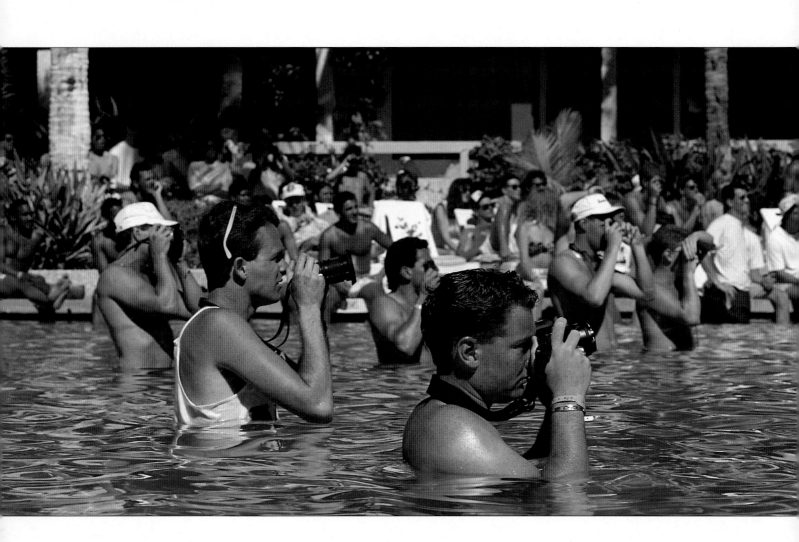

## SPRING BREAK

▲

Mention "spring break" and most people think about Ft. Lauderdale, Florida, the Gulf Coast of Texas, and Palm Springs, California. That was the 1980s. Today, thousands upon thousands of semester-weary students pile out of their dorms and frat houses to party down for a week in Mazatlán, Mexico. Coming from as far away as North Dakota, British Columbia, Chicago, Texas and Japan, they flee the grip of winter and descend on the border town of Nogales to ride Mexico's equivalent of the Orient Express: Ferrocarriles Nacionales De Mexico, an 18- to 27-hour, 750-mile train ride through rural Mexico to the gold coast of Mazatlán. Once there, most "aren't leavin' till they're heavin'," to use their expression.

I'd pitched the idea to Gamma-Liaison, under the title "Spring Break South of the Border: Riding the Rails to Mexico's Riviera." Rather than wait for a magazine to assign the photo essay, Jennifer Coley and I agreed it was a good enough story to co-produce; in other words, the agency and I would split the expenses of doing the story on speculation, as well as the profits once the story was put into domestic and foreign distribution.

The key to the story, I thought, would be to hook up with a group of college students and follow them around the clock. Not long after I talked my way onto the overbooked train lumbering out of Nogales, three seniors from Pomona College told me their buddy missed the train and wanted to know if I needed a place to stay in Mazatlán. Perfect, I thought. Their screening process was simple: they wanted to be famous, and they wanted to know what my "top ten heavy metal bands" were.

I slept on the balcony of our fifth-story, ocean-view hotel room, and I followed the trio around the clock. In the end, though, they weren't the focus of the essay, primarily because their vacation was limited to closing the cantinas at night and recovering by day. I photographed my share of that, but I wanted a larger view of what one Mexican lady told me: "Gringos do things in Mexico they wouldn't consider doing in their own country." Five weary days and nights later, I'd thought I'd run out of picture possibilities because I had covered everything from para-sailing to wet T-shirt contests, local Indian traders to cliff divers. I was in serious need of sleep—and a vacation—when I heard there was a tan contest. I couldn't resist.

A thousand or more students were gathered around an immense pool at the El Cid resort to judge a group of buffed-out coeds jiggling their greased limbs to piped-in disco music. I worked the scene backstage, as well as the crowd, then I hopped into the pool to see if I could get a closer photo of the contestants. Standing in chest-deep water to my left, however, were six students who were also interested in getting a better picture. Photographers sometimes turn their cameras on each other, and that's where the action was for me at that moment.

## SLEEPING BEAUTIES

▼

Three days after I returned from photographing the Taos High School Prom for its "Prom Night USA," I got a call from Life asking if I wanted to photograph the Saguaro High School Prom in Scottsdale, Arizona that weekend. With the beat-up pickup I was driving at the time, I knew I'd never blend into the posh resort town crowd of Scottsdale and pass myself off as one of the local bluebloods. Fortunately, Jim Hills lent me his credit card, and I rented a brand new, gun-metal gray BMW to go with my white tux and black corsage.

As at Taos, I decided to pre-script this as-signment and follow the reveling seniors around the clock. *Life* stringer Pam Hait was there to lead the way. One of our first stops during what turned out to be a continuous 36-hour shoot was a swimming pool. If Taos' chilly mountain air was any indication, I assumed the other half-frozen photographers working on the same essay in cooler climes across the country wouldn't have the opportunity to photograph sunbathers—and it might make a good picture.

Now, photographing these sunbathers might not seem like it has anything to do with high risk, but if you cut your teeth in an Italian neighborhood on Chicago's south side, as I did, you know how well fathers guard their daughters. Such was just the case when, with some trepidation, I eased into the pool to take this photo of Mary Caroselli (foreground) and Jill Langley, with Mary's father breathing down my neck.

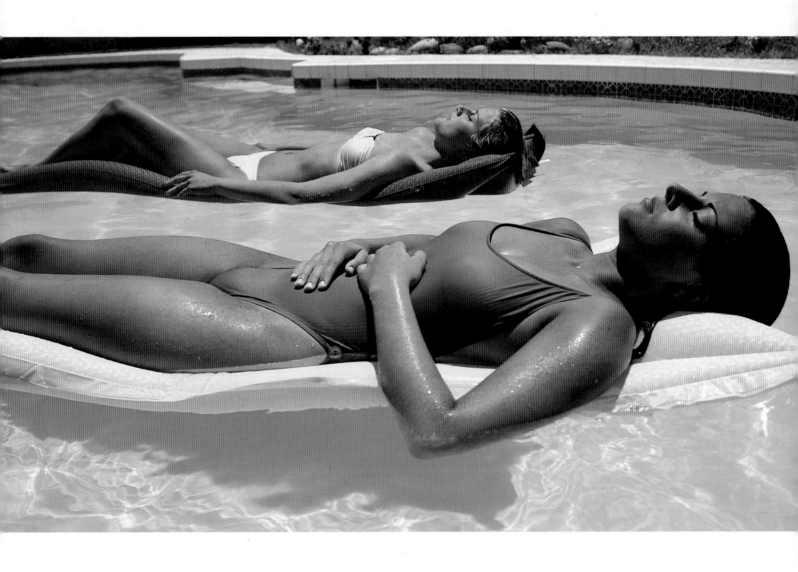

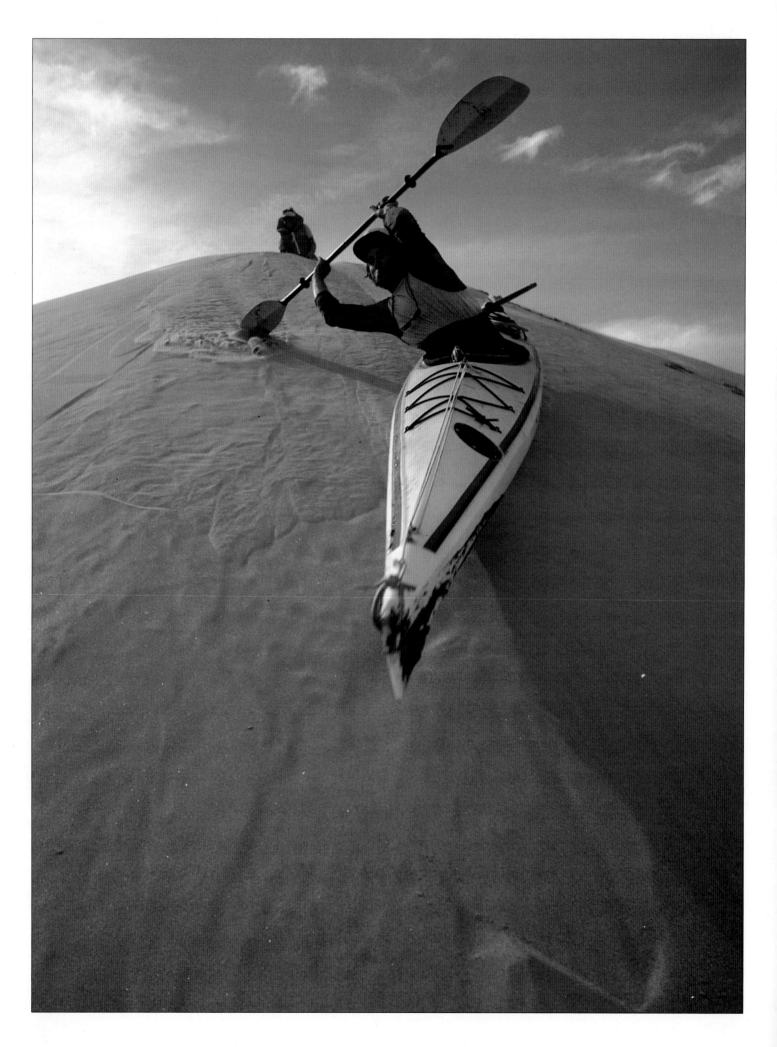

## Sea Kayaking

◄

Not long ago, Eskimos plied the frigid waters of the far north to harpoon whales from fragile sealskin kayaks. The whale hunting season was dangerous and desperately short. During the fall, pods of gray whales began their annual migration from the Arctic Circle to the warm waters off Baja California Sur; it was here the gray whales came to spawn in Baja's sheltered bays, before training their calves for the 5,000-mile journey back to the Bering Strait in the spring.

It was here, off the coast of Baja a century later, where modern sea kayakers were trying to pick up where the Eskimo left off. Only they'd come to watch, and photograph, the gray whale—not to feed a village. We had taken a lunch break on our five-day paddle across Magdelena Bay when expedition leader Kent Madin demonstrated a kayaking technique the ancient Eskimo paddlers couldn't have possibly known about; I was at the bottom of the dune waiting for him.

## Wings of the Apache

▼

Famed war photojournalist Robert Capa has often been quoted as saying: "If your pictures aren't good enough, you aren't close enough." Capa knew that better than anyone. His photo of a Spanish soldier falling backward the moment he is shot was a landmark in war photography, perhaps rivaled only by Eddie Adam's Pulitzer Prize–winning photo of a Vietnamese police chief shooting a suspected Viet Cong in the head. Both photos shock the viewer with the brutal realities of war.

Despite exceptions in recent years, most movie makers tend to gloss over the grim truth of war. *Wings of the Apache* was no different; worse, it was more of a commercial for the Army's state-of-the-art AH-64 Apache attack helicopter than it was a vehicle for its stars. Co-starring Tommy Lee Jones, Sean Young and Nicolas Cage, the story centered around an elite unit of Apache helicopter pilots dispatched to destroy the Colombian drug cartels on their own turf.

The day the "American staging area in South America" was to be bombarded by enemy gunships, the press was invited onto the set to cover the filming. On assignment for Gamma-Liaison, I had two days to photograph the stars and to "get whatever else you can get" before the set was closed down. Having worked extensively around helicopters as a heli-tac crew boss during the summer forest fire season, helicopters have always fascinated me; with a helicopter like the Apache, equipped with "fire and forget" Hellfire missiles, I immediately began thinking photo essay. So once I'd photographed the principals, I concentrated on filling in the rest of the pictures so I had a story that hung together.

The key photo, naturally, was when the American military base comes under siege. Had this been a real war, I'm not exactly sure what I would have done, but I assume I would have tried to get closer to the action. On a movie set like *Wings of the Apache,* which was using its share of pyrotechnics, there are defined boundaries you cannot go beyond: namely, you can't get in the way of production, and you're not supposed to get blown up. Lying on my stomach near the first unit camera, I realized I pushed in as far as I dared when my lens and face were blasted with sand by dirt bombs while I was taking this photo of (left to right) Tommy Lee Jones, Nicolas Cage and Sean Young running for their lives.

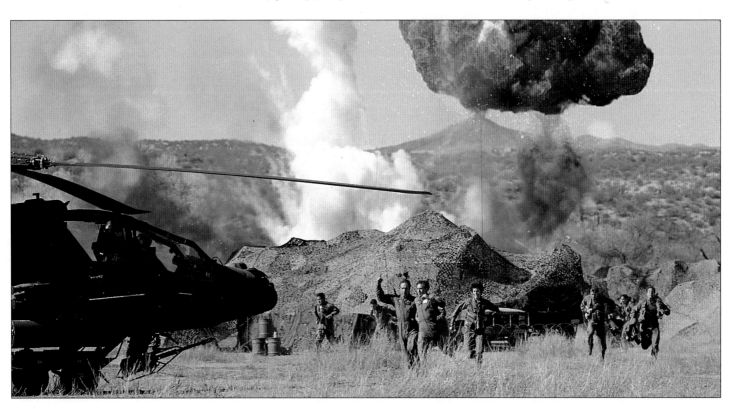

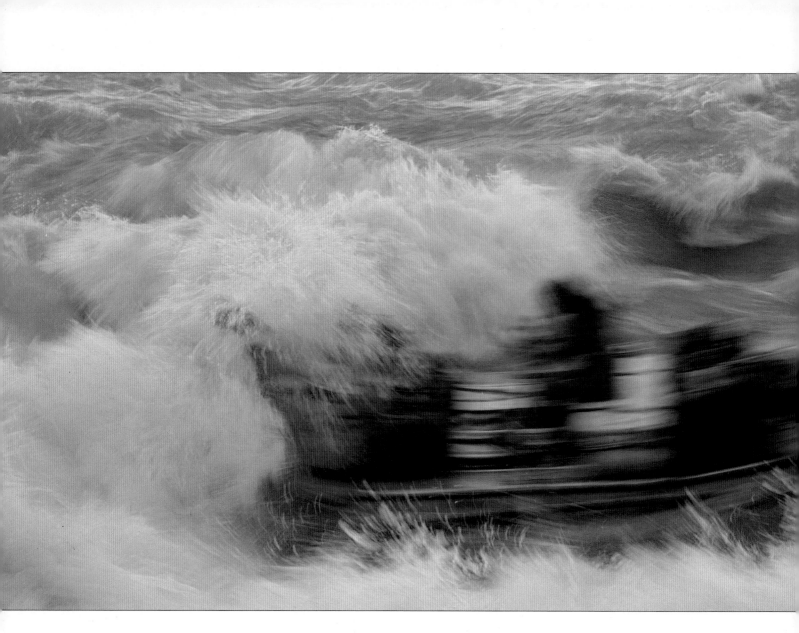

## HOUSEROCK RAPID

▲

River running in the Grand Canyon has come a long way since Major John Wesley Powell first ran the Colorado River in a wooden boat in 1869; in fact, before 1950, fewer than 100 people had run the wild Colorado River, and at least thirty-eight people had died trying. But today some 22,000 people raft all or part of the Colorado River each year, and they run it in everything from bus-sized motor rigs to small, oar-powered inflatable rafts. And, even though the once-mighty Rio Colorado, "Red River," has been harnessed, the enduring magic of the river lives on.

When Major Powell's second expedition down the Colorado River wintered over at Lee's Ferry in 1871, some of his men named Houserock Rapid while surveying the country above the river. Wrote Frederick S. Dellen-

baugh: "About sunset, we passed two large boulders which had fallen together, forming a rude shelter, under which Riggs or someone else had slept, and then jocosely printed above with charcoal the words 'House Rock Hotel'…We called it the same."

For my "Enduring Magic" photo essay, I wanted a series of photos capturing the magical quality of this historic rapid. However, when we reached Houserock Rapid on the morning of Day 2, the inner canyon was still cast in early morning shadow; I didn't want to switch to a faster film for fear of what the graininess would do to the overall look of the essay. So I ran across the ledgetop trail overlooking the rapid and used a slow shutter speed and fill-flash to show this boatman plunging through this mysterious wave.

## THE STRETCH

▶

In rodeo, saddle bronc, bareback and bull riding are known as the roughstock events, generally recognized as the most dangerous events in rodeo. Few spectators, however, visit the site where the nerve-jangling excitement of these explosive rides can reach its peak: behind the chutes.

The stretching routine in particular is done as much to limber up as to control pre-ride jitters before climbing onto 1,000- to 2,000-pound animals that would like nothing better than to kick, stomp or gore riders to a pulp.

Prescott's Frontier Days Rodeo has long boasted that it is the "World's Oldest Rodeo"; while shooting behind the chutes there, I was struck by the strong graphic composition of this hometown bullrider stretching across the white railings of this empty bucking chute.

# LEAP OF FAITH

▶

People jumping have always fascinated photographers. Some images, like amateur photographer John Gilpin's photo of a man falling out of a Japan Air Lines DC-8, was taken strictly by accident. Stanley Forman's Pulitzer Prize–winning photo of a woman and child plunging from a burning building, however, was taken because the news photographer was covering the tragic fire and because he had the talent to take the extraordinary photo. Still other photographers took a lighter view of jumping, as did Phillippe Halsman when he photographed a book of statesmen and celebrity portraits called *The Jump Book.*

Humorous or tragic, jumping no doubt had its origins in the dawn of civilization. Among the first people to recognize the thrill of jumping, however, were reportedly the South Pacific islanders from the archipelago of Vanuatu. Their young men plaited vine ropes, tied them around their ankles, and leaped from high towers to show their courage.

Recently, "land diving" has surfaced in the United States via New Zealand as bungee jumping. But if land diving was associated with culture and ritual, modern bungee jumping is more closely aligned with thrill and stealth. Unless they're bungee jumping from a hot air balloon tethered to the ground, bungee jumpers generally violate trespass and public nuisance laws. That's where the stealth comes in—and what fascinated me about shooting an essay called "A Bridge Too Far: Bungee Jumping in the Painted Desert." Not only do bungee jumpers have to find a suitable bridge, but they have to sneak onto it, set up their rigging and hundred-foot–long bungee cords, jump everyone safely, then sneak away without getting caught by the local gendarmes. One of my favorite photos from the initial take of a group called Free Fall Bungee was of this man flying off a 200-foot-high railroad bridge somewhere in the Painted Desert.

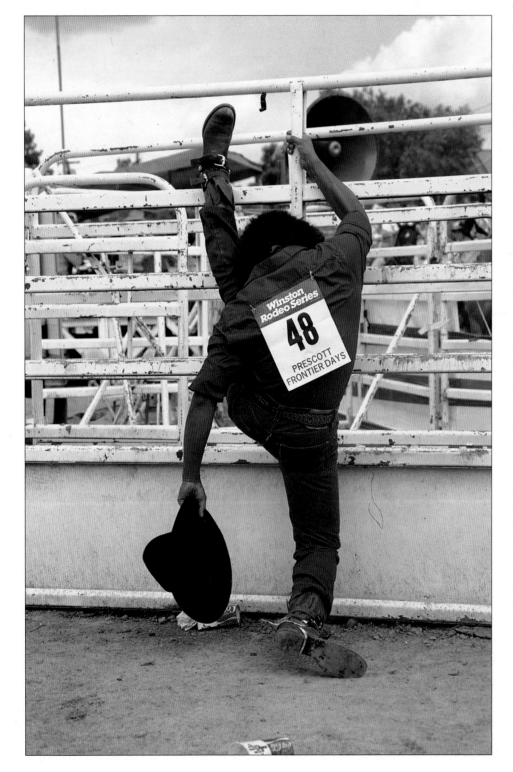

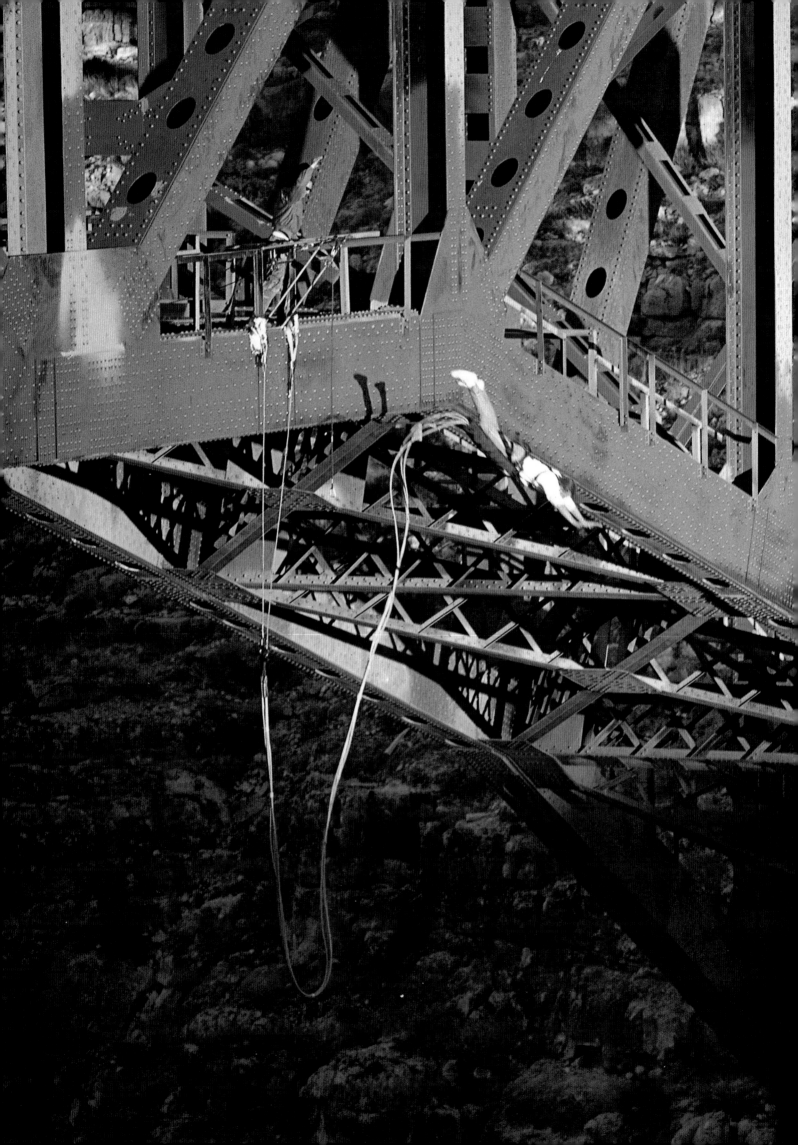

# PORTRAITS

## NANCY DICKINSON

▶

*Nestled in the rugged, pine-clad Bradshaw Mountains of central Arizona, Friendly Pines Camp is the quintessential American summer camp. Since 1941, its founders, Bud and Isabelle Brown, have tried to instill in its campers "wholesome values based on western traditions." A half-century later, Friendly Pines has become internationally re-nowned for just that reason. At a time when other summer camps across the country have folded up their tents and tallied their losses like stacks of cordwood, Friendly Pines has taken the summer camp experience beyond the realm of an American tradition. Said former Royal Air Force fighter jock Jack May, who co-directs Friendly Pines with his wife Bebe, a second-generation Brown: "We try to imbue a sense of internationalism into our youngsters, so they may become citizens of the world and not just citizens of America."*

*I'd spent a week at Friendly Pines, photographing everyday camp activities that ranged from horseback riding to basket weaving, when one afternoon I chanced upon an impromptu mud fight. I jumped into the melee, trying to cover my camera as I shot. Everybody lost, it seemed, drenched as they were with greasy mud and water. Except for some mud smeared across a lens and motor drive, though, I managed to get out of the fight without completely trashing my*

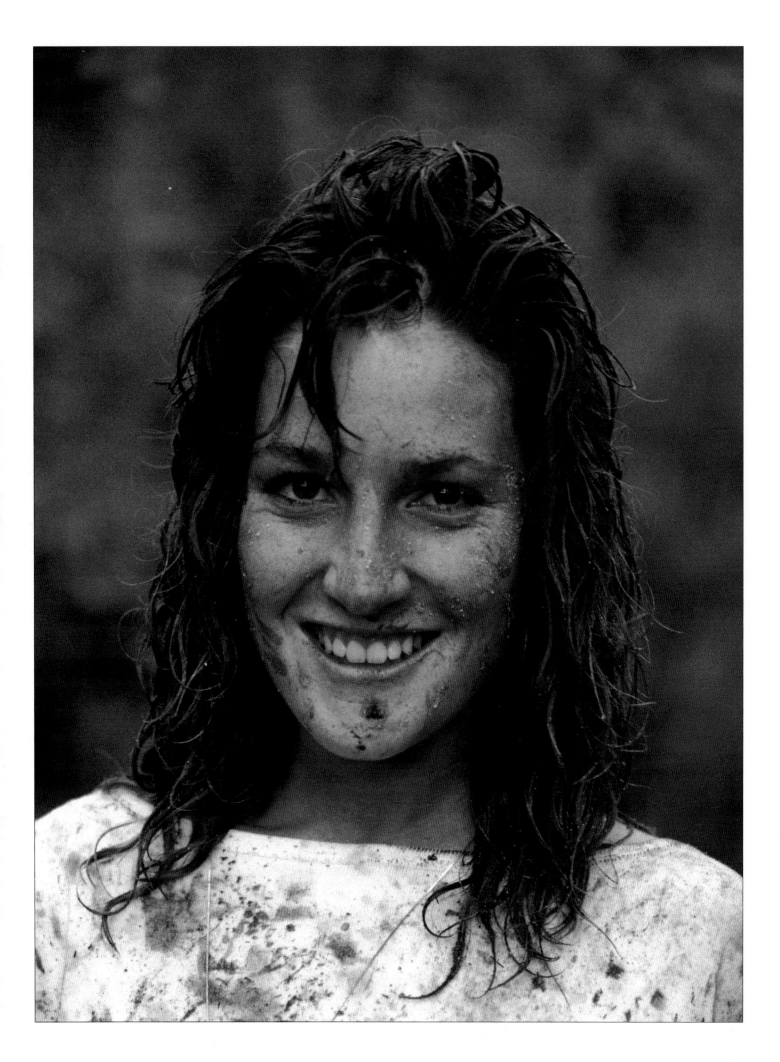

equipment. Then again, I'd come to believe that getting the photo is more important than keeping your cameras in archival condition. The light was fading fast when I noticed a counselor, Nancy Dickinson, just standing in the mud with this sparkling grin on her face. I was worried the picture would be soft, because I was already trying to compensate for the dim light with slow handheld exposures, but I took her portrait anyway. I'm glad I did, because I think her captivating looks shine through it—mud and all.

## MARCELINO RUIZ AND HIS GRANDDAUGHTER

▶

Campo 35 is one of hundreds of small, desperately poor agricultural villages scattered across rural Mexico adjacent to large corporate farms. Located near Los Mochis, Sinaloa, 600 miles south of the U.S. border, Campo 35 has for decades been a bedroom community of American farms, because its men have provided the United States with a cheap dependable migrant work force.

Not long after I'd photographed my first border crossing, I went to Campo 35 to photograph the four men I'd crossed the desert with. I wanted to show them with their families. But I also wanted to show the economic conditions that drove young fathers like them away from their homes and families to try crossing the deadly American desert.

When I arrived in Campo 35, though, I learned that two of the four men had already gone north again. Their wives told my interpreter and friend, Jim Hills, and me they didn't know where the men had gone to look for work, nor would they know until they received a letter—with money in it, they hoped. Jim and I looked around and suddenly realized the vil-

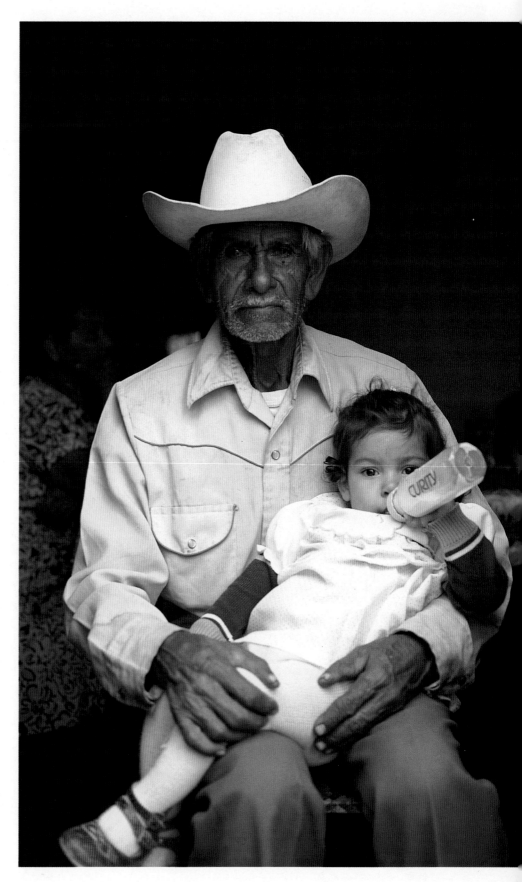

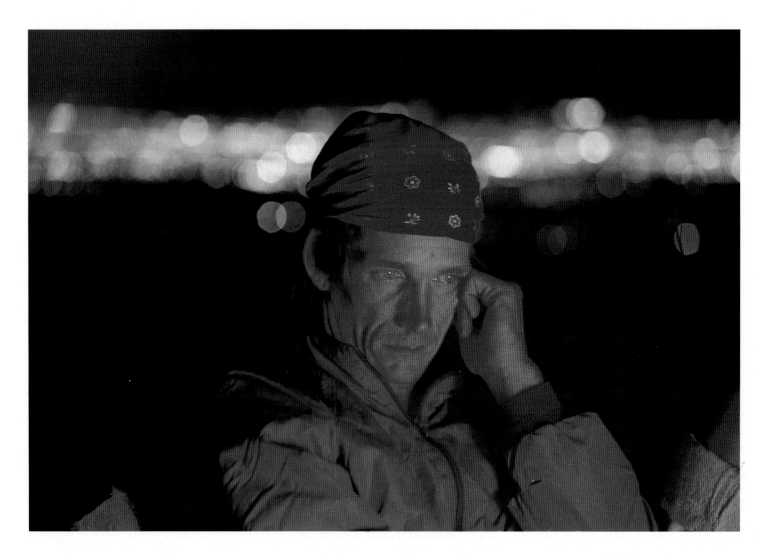

lage was filled with mostly women, children and older men.

Marcelino Ruíz was one such man; he was the father of Rosario, one of the men I crossed the desert with. Unlike many other men from Campo 35, Marcelino has never been to the United States and said he wasn't interested in going. At the time, he'd just returned from working ten hours a day in the fields for 7,500 pesos a day (US$3). Jim was talking with Marcelino's wife, Porfiria, while she rolled out corn tortillas with an empty bottle, when I noticed Marcelino was sitting by the doorway, with his granddaughter Diana sitting on his lap. I asked if he would turn his chair around so there would be enough natural light to take his picture. He did and, to me, this portrait represented the population of Campo 35 at the time.

## RANDY MULKEY

▲

A formidable wall of 4,000-foot-high granite peaks, the Sierra Estrellas is one of the Southwest's most rugged, least explored mountain ranges. When hydrologist Kirk Bryan surveyed the region in 1917, the Sierra Estrellas were among the few desert ranges where the United States Geological Survey failed to discover any perennial water sources.

That's why most early explorers avoided the Sierra de San Joseph Cumars, as they were called by Fray Francisco Garces in 1775—including the dauntless Father Eusebio Francisco Kino, who had skirted the southernmost flanks of the Sierra Estrellas as early as 1699. Even the Pima and Maricopa Indians who lived, farmed and fought hostile Yuman and Mojave Indians within the shadows of Kamatuk had, according to anthropologists, little reason to climb its jagged upper reaches. In short, when medieval

cartographers pointed to the blank spots on their maps and said, "here be the dragons," they might as well have been describing the Sierra Estrellas, "mountain of stars," a mere twenty miles southwest of today's Phoenix.

That's exactly why I wanted to traverse the twenty-five-mile-long, serrated crest of the Sierra Estrellas from one end to the other. I wanted to see for myself why they'd been avoided by Indians, explorers and mountain men. Randy Mulkey agreed to join me. But we didn't know whether we could physically carry enough water to support our climb and struggle over such difficult terrain. Caught by a rising thermometer on Day 3 of our four-day epic, we were sitting around a bivouac fire pondering our options when we suddenly realized there was a strong possibility we might die of thirst within sight of downtown Phoenix. That's when I took this portrait of worried Randy, lit by firelight and backlit by the nighttime megalopolis.

## RESCUE-1

▼

From time to time a brief article appears in *The Arizona Republic* footnoting that an F-16 from Luke Air Force Base had crashed on a training mission, and that the pilot's name and condition were being withheld pending notification of next of kin. Such cryptic accounts about $20 million of supersonic technology crashing in the desert always disturbed me. I never knew how the story ended: whether the pilot was lucky enough to "punch out" of his doomed jet before it bored a hole big enough to bury a bus, or whether he rode it all the way in. Or, if the pilot did manage to eject safely, who rescued him and how.

I made some phone calls to the Marine Corps Air Station (MCAS) in Yuma and eventually was routed to Major Bruce Lohman; at the time, he was Search and Rescue Officer in-charge of a helicopter-borne search and rescue wing called Rescue-1. Their primary mission was to locate and evacuate downed aviators in some 1.5 million acres of austere desert bombing ranges throughout California and Arizona. I wanted to do a photo essay. Major Lohman made it happen.

Before we left the flightline at MCAS for the first training mission, though, I wanted a portrait of a typical Rescue-1 crew: left to right, Sgt. D.J. Valdez, Crew Chief, U.S. Marines; H.M.-1 Noel Ramirez, Corpsman, U.S. Navy; Major Bruce Lohman, Helicopter Pilot, U.S. Marines; Sgt. F.C.C. White, Crew Chief, U.S. Marines; Lance Corporal J. Bishop, Crew Chief, U.S. Marines.

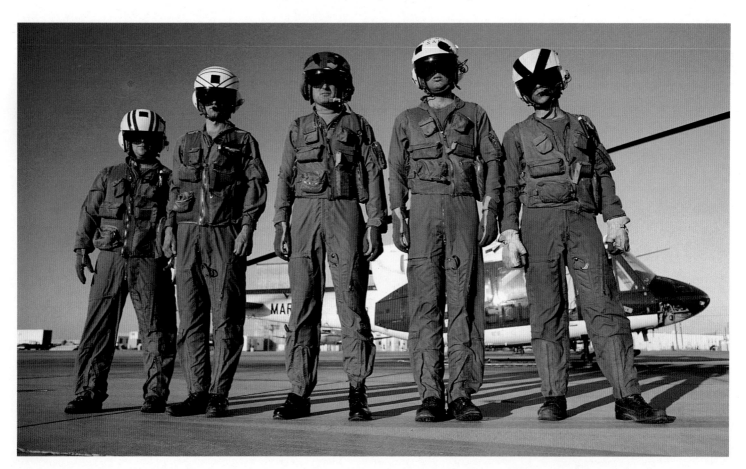

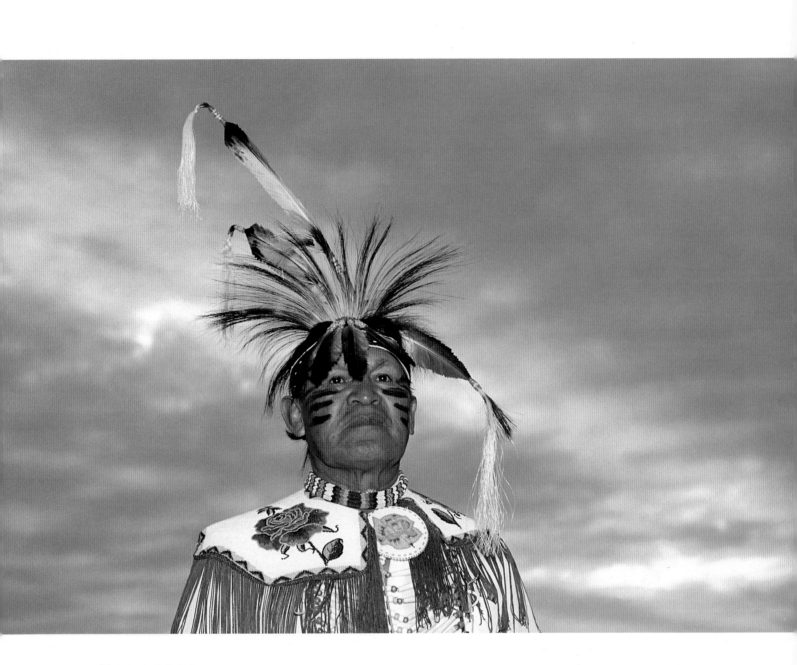

## POWWOW

▲

Native Americans gather at powwows across the country to sing tribal songs and perform ceremonial dances. I went to photograph my first powwow at Kino's historic San Xavier Mission on the Tohono O'Odham (formerly Papago) reservation. It was midday and the light was washed out, so I wasn't planning to take any pictures until late in the afternoon, when the desert would be saturated with color. Cloud cover moved in, however, and the light didn't peak until twilight when I photographed this man, using fillflash.

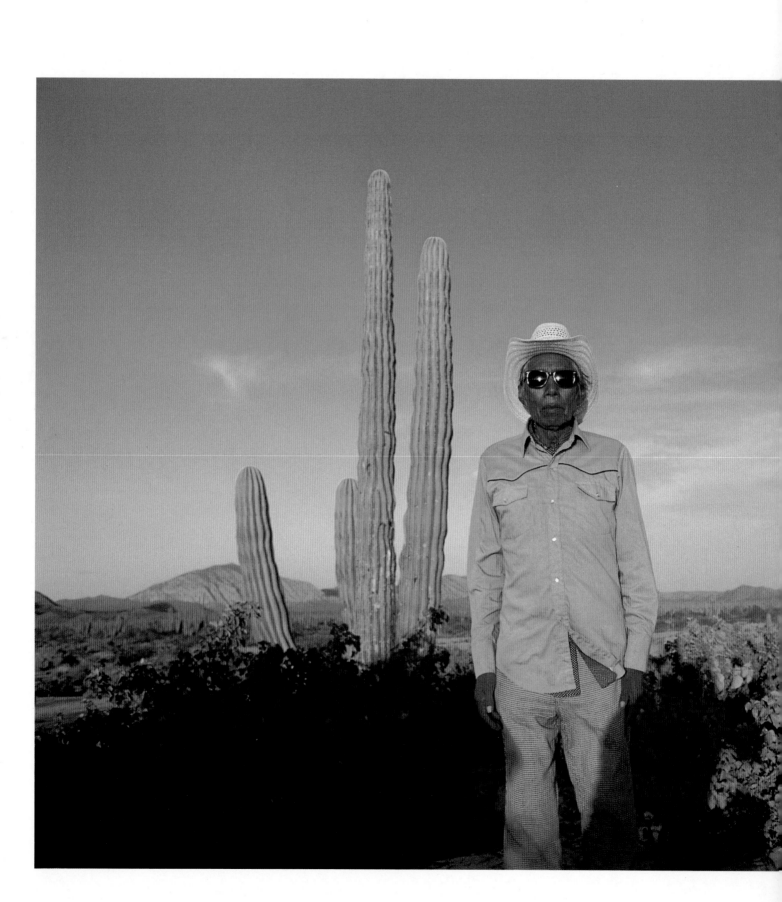

## SERI ELDER OJENIO MORALES

◄

The first time I visited the Seri Indian village of Desemboque on the coast of Sonora was during the summer of 1983. Jim Hills had been trading with the Seri for twenty years, and I had gone with him, among other reasons, hoping his presence would make it easier for me to photograph the people. But Jim warned me the Seri were notoriously camera shy; in fact, I soon discovered, if you persisted and someone didn't want his or her picture taken, they'd cover their faces or pick up a dead fish and throw it at you until you put your camera away. That taught me a valuable lesson: if you are trying to shoot a candid portrait, and somebody doesn't want it taken, chances are it's not going to make a good picture anyway.

That first trip to Desemboque also taught me something else about photography and trust. Until someone trusts you, you're not going to get the pictures you really want. Since then, I've always tried to establish that bond, if possible, before I take someone's picture. That was especially important for me, because I prefer to work close, using longer lenses only to change the pace of the photography, or composition, or shoot what I can't get any other way.

Eight years went by before Jim and I went back to Seriland together and, by then, I was more acutely aware of who wanted you to make them "famous," who was likely to show you a side of themselves they might not show anyone else, and who might throw a rotten fish at you.

Jim was sitting at our beachside camp, bargaining for handmade baskets and ironwood carvings with a handful of Seri women, when an older Seri man came up to me. I don't know what I had done, other than he saw me pouring coffee for everyone and taking a few pictures of the trading. But he pulled me aside and told me in Spanish he was going to die soon. Would I take his picture? I was stunned, yet, I felt honored—I felt trusted. I immediately thought about doing a tight portrait to show his dignity and age; then, I thought it might be better to do a portrait of him within the environmental setting of "his place," what they call *lisitim.* The late afternoon light was peaking when he stood in front of this tall cardon cactus.

# The Iguana Brothers

▼

During spring break, college students make a beeline for Mazatlán's *zona dorada,* "golden zone"; it's a strand of public beach north of colonial Mazatlán characterized by high-rise hotels, expensive discos, restaurants and gift shops. One of the things that struck me about the zona dorada was that, despite such opulence, Mexican and Indian artisans were hawking their arts and crafts to the norteamericanos. Had this been the states, these artisans, many of them obviously dirt poor, would have been considered "homeless." But here, that term didn't seem to exist; it had been replaced with hard work and ingenuity.

One of the more enterprising groups of locals that approached me while I was photographing the spring break story, were the stylishly-coiffed "Iguana brothers"; they strolled the beach daily, offering tourists the opportunity to "Take our photo for five dollars." Up till then, I'd never paid anyone to take his picture, but a portrait of the "Iguana brothers" was one I couldn't pass up.

# Sean Young

▶

When I approached Sean Young to take her portrait I wanted something other than the studied head shots I'd already taken of her on the set of *Wings of the Apache*. But I didn't want to ambush her like a paparazzo. So I waited until she was finished fielding questions from the press and made my request. Satisfied the pictures would not be used in any of the scandal sheets, she readily agreed, and asked me what I had in mind.

I really wanted to photograph this lithe actress on one of the Apache attack helicopters, but the midday light was too harsh on her soft, light complexion. In the end, I was glad I'd grabbed those first candid portraits in the shade; because I felt they came closer to capturing that mysterious allure Young exuded as the replicant in Ridley Scott's steamy sci-fi thriller *Blade Runner.*

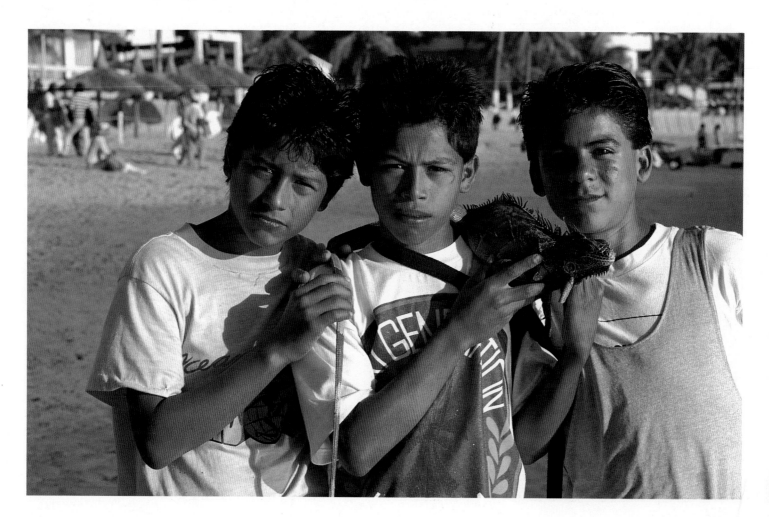

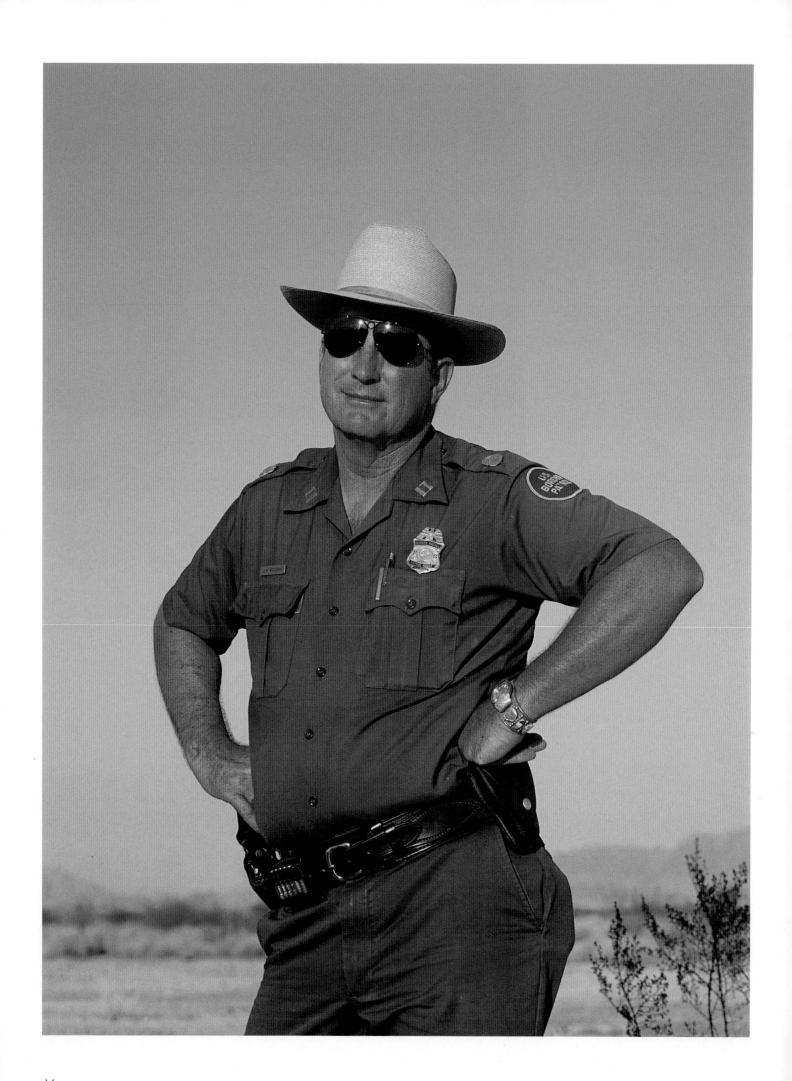

portraits

## MANHUNTER JOE McCRAW

◄

When I first started working on *Path of Fire,* I didn't relish the thought of spending much time with the Border Patrol, mainly because I felt—and still do—that anybody who walks fifty to seventy miles across the desert during the summertime to work has earned the right to be here. Period. Still, I didn't want my personal feelings slanting the essay; rather, I wanted to cover every aspect of the story as thoroughly as possible. So I led off with the Border Patrol.

Border Patrol tracker Joe McCraw soon set me straight—at least about what he and a handful of other agents did, from their hardship post called Tacna. In fact, Joe admitted to me: "You have to admire somebody that will get out and walk sixty miles just to get a job." But, in the next breath, Joe added: "I often wonder how in the world a guy can even think he can come across that desert walking thirty, forty, fifty miles."

Not all of them make it; that's where a handful of dedicated trackers like Joe McCraw come in. Greatly feared in Mexico as *la migra,* "immigration," men like Joe don't just "catch

'em and throw 'em back." Using the ancient Indian art of "sign cutting," and jeeps, they've saved more than 200 people who otherwise wouldn't have made it across this merciless desert alive.

I'd spent five days photographing Joe and his men tracking people across the blistering desert—with the help of pilots who fly low enough to track from the air—and I was worried I still wasn't showing the dangers of the crossings. So I asked Joe: "Is there any other way I can show how dangerous it is to cross the desert other than by making a crossing?" Joe stopped the jeep, then said, "No...but I can arrest you for aiding and abetting if I catch you." I told him I was only interested in photographing both sides of the story and didn't mention it again. But I took this portrait of Joe later that afternoon, when he realized he might be tracking me some day. In the end, though, it was Joe who went to bat for me when his superiors found out I'd photographed a crossing—ironically, on Joe's days off. Joe reportedly told them, in his Arizona drawl, "Dad blame it, he's just trying to show both sides of the story."

## "JOHN DOE MEXICAN"

▼

Depending on who's counting, anywhere from 100 to 400 Mexican citizens have died "commuting to work" across the desert during the last decade. Even with near-legendary trackers like McCraw cutting sign, it's impossible to find everyone who "goes down." The sheer scope of the killing ground, 3,500 square miles, makes it difficult for trackers to locate many of the bodies; they decompose rapidly and are either covered by blowing sand or torn apart by animals and scattered over wide areas.

When a body or skeleton is discovered without identification, the Yuma County Sheriff's Department oftentimes calls them John Doe Mexican on the Incident Report. The first time I photographed "John Doe Mexican," he was lying on the desert floor a mile east of a waterhole the Border Patrol calls Game Tanks and Mexican citizens sometimes call *agua de venado,* "deer water." What I found particularly tragic about this man's death was that he'd managed to come forty miles across the desert, only to die a mile *after* he'd reached the only known waterhole. This is my portrait of him, whoever he is, God rest his soul.

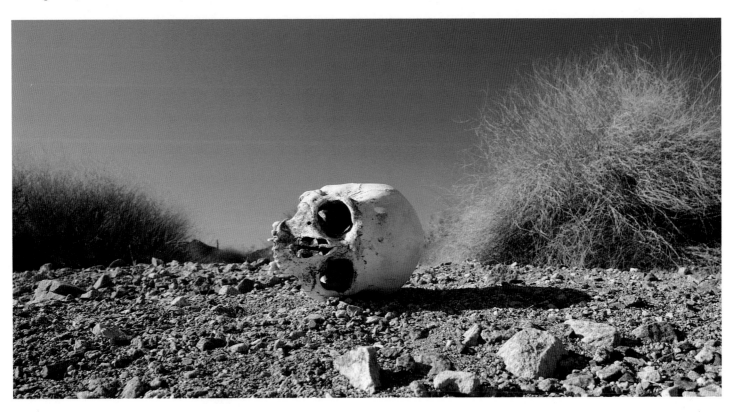

# NIGHT

## MEDICINE MAN AND WOMAN

▶

Some native peoples around the world tell photographers, "If you take my picture, you'll steal my spirit." I've often been at odds with my conscience over how to photograph even willing Native American for various assignments without stealing their spirits.

On an architectural shoot at an upscale housing development being gouged into a pristine tract of Sonoran desert, I was told an ancient Hohokam village had been unearthed during construction. The developer recognized the significance of the site and called an immediate halt to construction. He hired a university team to excavate the site. Among the wealth of ancient artifacts unearthed was a rare

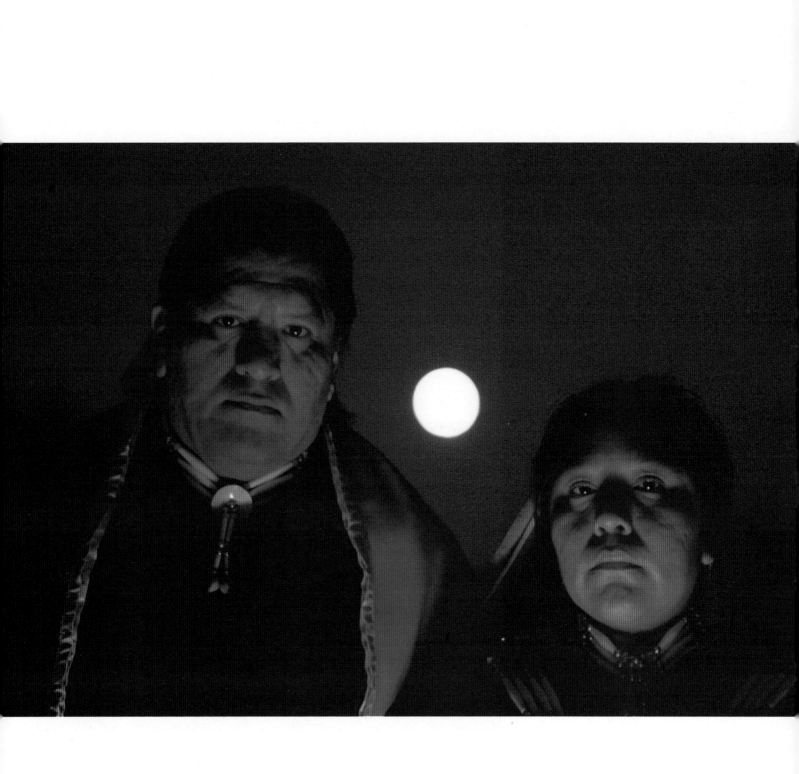

copper bell, of which only fifty were reportedly discovered in the history of Southwestern archaeology.

I did a little "digging" myself, and one source who spoke on the condition of anonymity told me that a sacred Indian burial site may also have been unearthed. Sensing the possible sanctity of the area, the Pima and Maricopa Indians reportedly blessed the site. But I wasn't interested in photographing an Indian ceremony held in the glare of television lights and witnessed by throngs of spectators. Rather, I wanted to photograph the attending medicine man and woman in a light that I felt came closer to showing their true spirit and not stealing it.

Melvin Deer and his wife Katherine agreed to rejoin me at the dig site a week after the ceremony. But before I took any pictures I explained to them exactly what I wanted to do. Since a fire was reportedly used during the original ceremony, I wanted to use firelight to light them naturally, backdropped by a hunter's moon. I gave Melvin Deer one of my cameras so he could see what kind of picture I wanted to take. Fortunately, he was pleased with the scene and sat behind the fire with his wife. As the moon crept over the horizon, I threw dry brush on the burning coals so I had more light. That's when I took this picture of Melvin and Katherine Deer.

# BUSTED

▼

I was photographing a story on National Park cops when Grand Canyon Ranger Ronnie Gibson told me, "Everybody loves to visit a national park—even the bad guys." Then, that's exactly what intrigued me about the story. But President Ulysses S. Grant wasn't thinking about "bad guys" when he signed a bill on March 1, 1872 creating Yellowstone National Park as the nation's first. Nor was President Theodore Roosevelt when he first visited the Grand Canyon in 1903. In a moving speech delivered there on May 6, Roosevelt proclaimed it a "natural wonder...absolutely unparalleled throughout the rest of the world."

"Bad guys" didn't cross his mind, either, when he declared the Grand Canyon was "the great sight every American...should see."

While covering night shift at Grand Canyon Village with ranger Brian Smith, I was looking for a single photo which said crime-in-a-national-park. Shortly after midnight, I got my chance. I was relying on available light and high speed film, because I didn't want to be obtrusive by using a flash. Fortunately, Ranger Smith handcuffed this suspect in front of the headlights to see what he was doing and I was able to brace my arms and camera across the hood of his patrol car to take this picture.

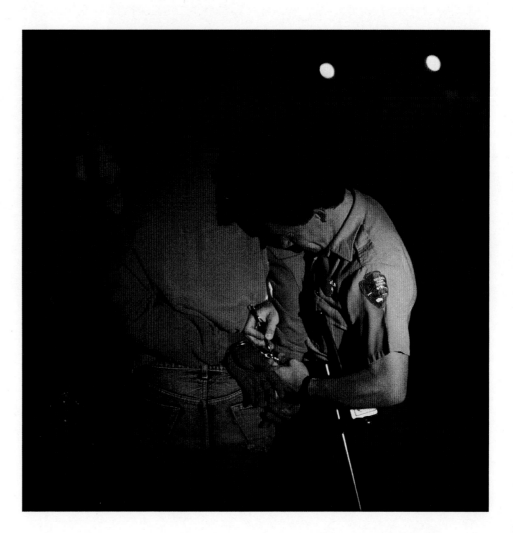

# KICKING OUT THE JAMS

▶

Shortly after I arrived in Taos, New Mexico to photograph the high school prom, *Life* reporter Naomi Cutner and I went to the school so I could photograph students decorating the gymnasium. As soon as we walked through the side doors, though, I was horrified to see the entire ceiling of the gym was being covered with rolls of papier maché—blocking out any light that might come from overhead.

Since this was my first *Life* assignment, I obviously had a lot riding on it; the cavernous gym only heightened my fears about blowing my one chance of breaking into *Life*. I mentioned to Naomi I wanted to outline a shooting script; she agreed on the approach. We broke the prom down into scenes to cover: girls making their dresses; boys being fitted with tuxes and washing their cars; girls getting their hair done and putting on their faces; guys buying corsages and picking up their dates; and finally the pre-prom dinner. But these scenes were only the buildup to the big dance.

When Naomi and I arrived at the dance, it was worse than I'd expected; it was tomb-black, except for a glittering glass ball that spun overhead. Unless I made use of the fickle source of light, I would be shooting in the dark. So I watched the flickering beams to see which couples they lit and how those couples looked. Satisfied I saw a random pattern in the lighting and how it played off the gowns and tuxes, I moved onto the dance floor and mingled with the couples, photographing them as they danced. That's when I noticed this acrobatic senior practicing what looked more like field goal kicking than dancing; I moved into position and took a series of photos of him. When *Life* used this as their opener for "Prom Night USA," I kicked up my heels too.

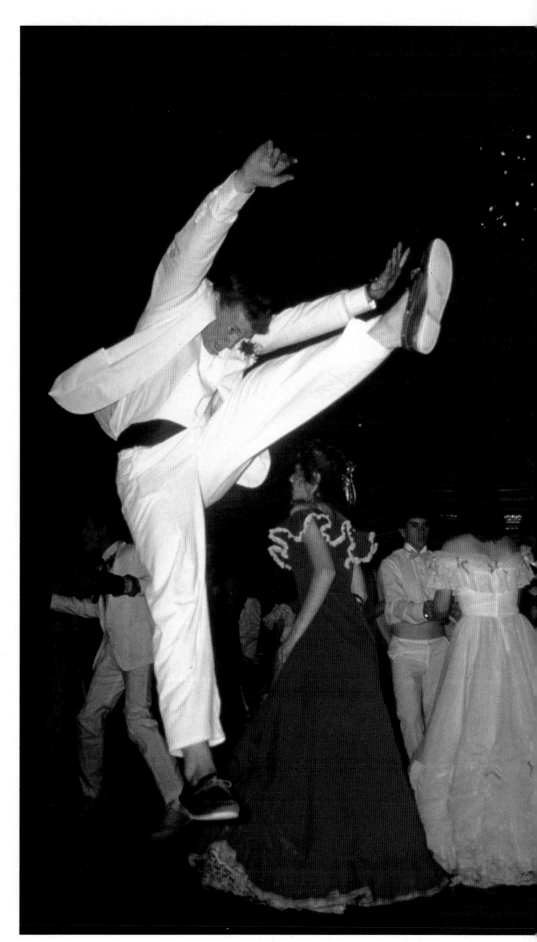

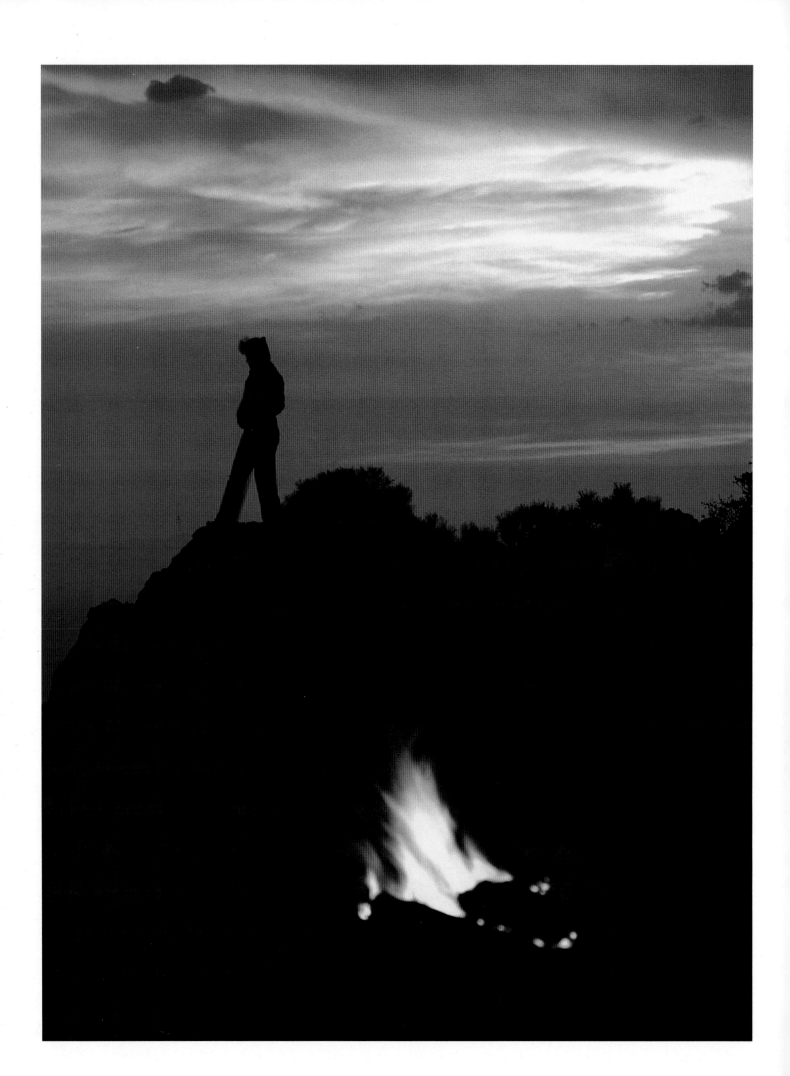

## QUEST FOR FIRE

◄

In Greek mythology, Prometheus stole fire from heaven and gave it to man by tricking the god Zeus. Since the dawn of civilization, man has been captivated by Prometheus' gift; he has used fire to fashion crude weapons, stampede and kill mammals, and cook their meat. By night, fire has warmed him through the chill hours of daybreak and to this day forms of fire remain man's tenuous link with the coming day.

I'd often thought of photographing such a scene, and finally got the opportunity when I climbed to the top of 9,453-foot Santa Rita Mountains. I'd gone there with the express purpose of photographing the dramatic 360-degree panorama from its craggy summit. But halfway up the pyramid-shaped peak, the clouds rolled in and I feared the glorious sunset photo I hoped for would be shrouded with a dismal gray cloudbank.

When Pat Orozco and I approached the summit late that afternoon, a damp chill permeated the air, so I quickly made a fire before setting up camp on a rocky overlook. The sun was dropping fast, and as it did it ignited the dreary cloudcover with a fire-red and -yellow glow. Pat had walked over to the edge to take one last look at the 4,000-foot climb we'd made to reach this perch, when I noticed the subtle similarity between the color of the firelight and the cloud cover. That's when I made this picture.

## HIGHLINE

▼

If tyrolean traverses were first used by rock climbers to get from one summit to the next, it is fitting that they've since been used by mountain rescue teams to evacuate injured climbers across deep glacial crevasses and gaping flood-swept chasms. Recognizing their dramatic appeal, Hollywood movie makers have also used highlines to get leading men from one perilous perch to the next.

The sun had already gone down when I stumbled onto this beachside highline in La Paz, Baja California Sur, and I was immediately captivated by the scene. A handful of children were still laughing and playing on the highline as if it were just another swing set—and I wanted that picture. But if I only exposed for the ambient light of twilight, I'd miss their laughter and joy because they'd be nothing but silhouettes; so I exposed for twilight and used a little flash to fill in the charm of the whole scene.

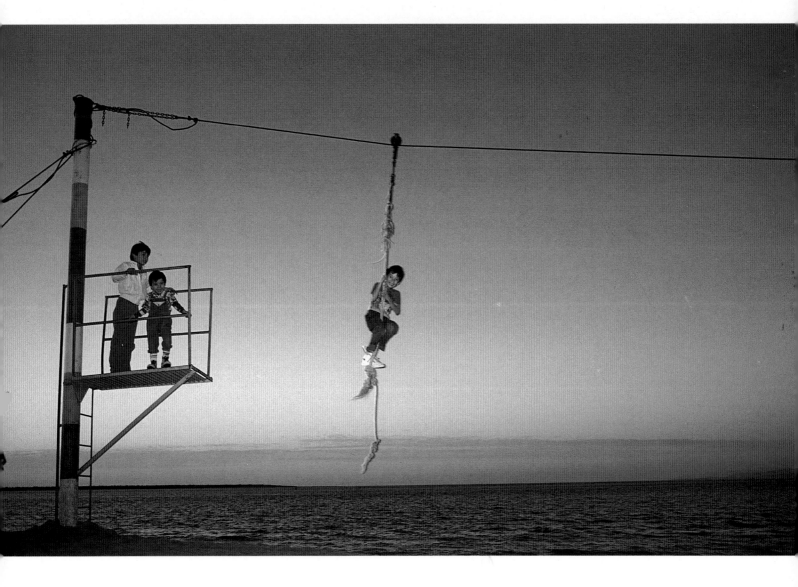

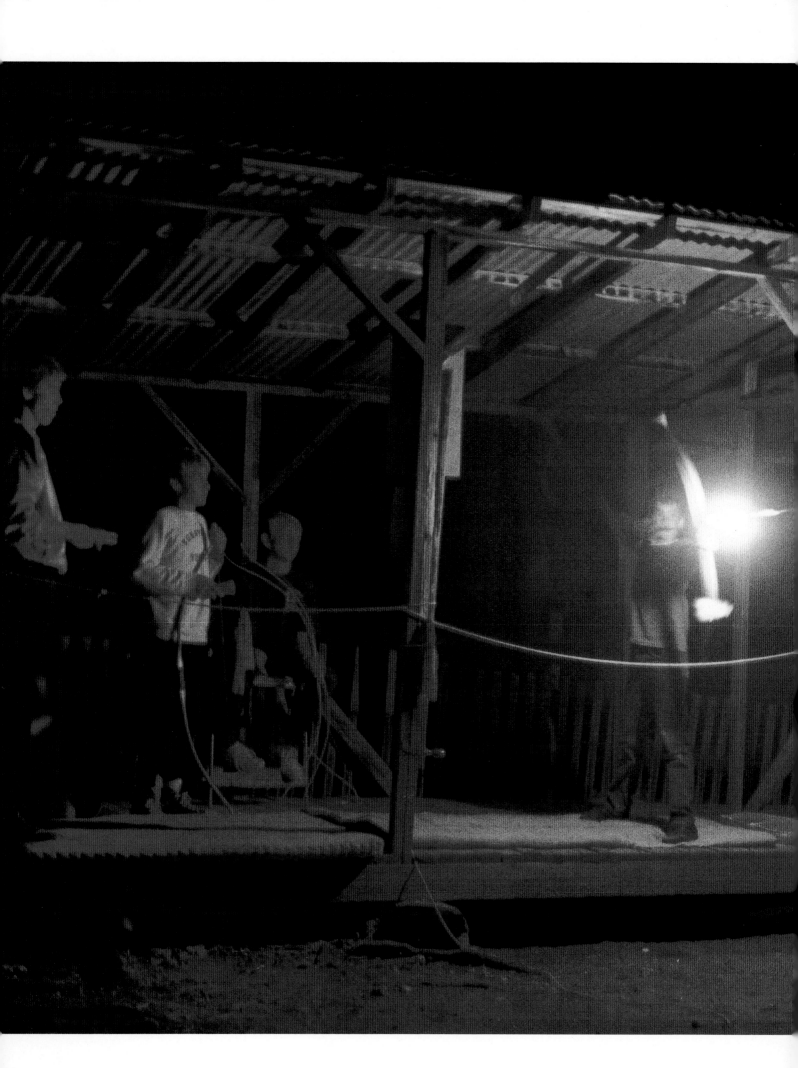

## NIGHTSTALKER

◄

I'd photographed archery at several forest camps for the summer camp essay, but I really wasn't excited about what I was getting. Catching the arrow mid-flight just as it left the bow was striking enough, but I wanted something more. I was at a loss as to how to improve on the situation when I remembered several movies depicting archers shooting flaming arrows at nighttime enemy encampments. I wanted to try something along those lines. So I bought a box of highway flares, cut off their tops, and taped those fuse-tips to a dozen or more arrows. I then enlisted the camp's top archers. As each took his turn, my assistant lit the fuse tip and had the archer draw back the arrow. Handholding the camera on a wooden fence post, I held the shutter open long enough for the flare to light the archer and onlookers before signaling him to shoot the arrow, whereupon I released the shutter.

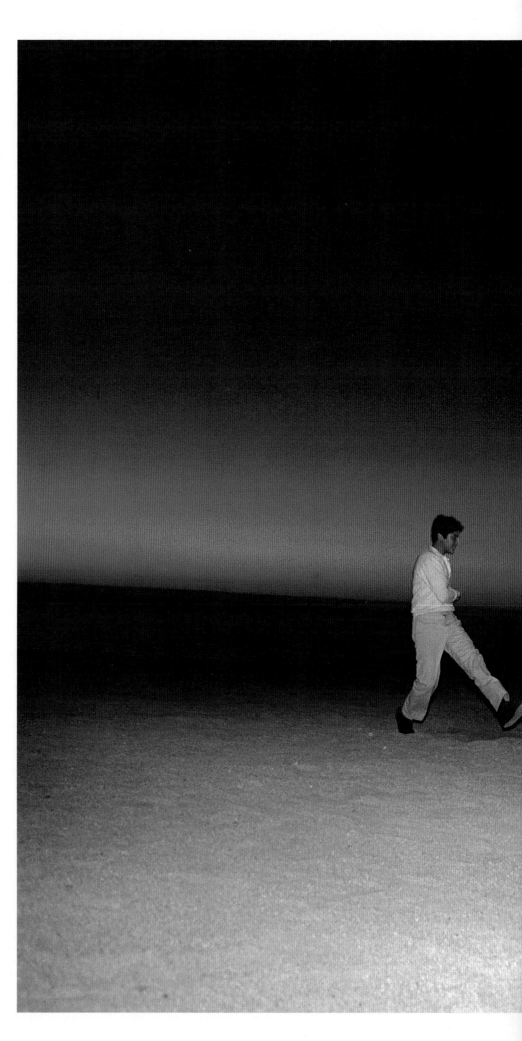

## SHOT IN THE DARK

▶

I'd just finished photographing the children playing on the highline (page 53) when I noticed a young man practicing soccer with a friend on the now-deserted La Paz beach. I knew Mexicans were passionate about their national sport, but I'd never seen anyone playing in pitch darkness before and, if possible, I wanted a picture of it.

Backlit by the faint glow of a wine-red sky, however, their black silhouettes moved back and forth too quickly for me to expose for them. I crouched low, hoping to follow the action a little better. That helped define their silhouettes, but I still couldn't see the ball—and without the ball, I wouldn't have a picture. Virtually blind to the scene, I started listening; that's when I recognized the sound of the ball each time it was kicked. I took several pictures with my flash, but I feared I'd missed the photo because I pressed the shutter after I heard the kick. So I tried anticipating the sound, making several more exposures when I caught this kick mid-flight.

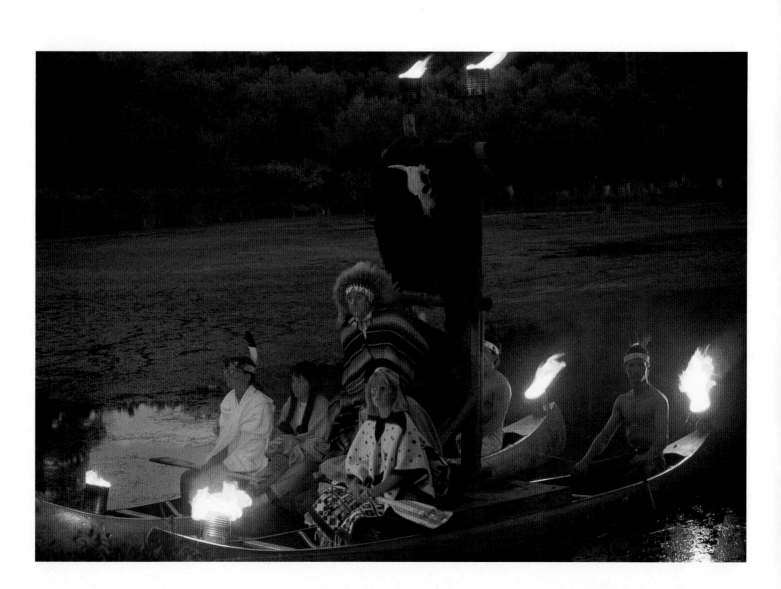

## COUNCIL FIRE

▲

Near the end of the summer camp assignment, I attended Friendly Pines' Council Fire, traditionally held at summer's end so campers could share stories and Indian lore, and be recognized by their counselors for the goals they'd achieved. At a small mountain lake hidden in a dark sweep of ponderosa pines, hundreds of campers waited in awe as this "Indian Council" paddled across the lake in their firelit cata-canoe. I took several pictures of them paddling across the lake at twilight, but I preferred the mystique of this firelit scene as the council listened to the shoreside achievements of one young camper.

## DREAMING THE FIRE

▶

Not long after I completed the last of the three 200-mile-long wilderness runs through the Grand Canyon, I began wondering if it was possible to follow another pathway of mine. Only this one went from Mexico to Utah, across 750 miles of Arizona wilderness and, unlike the Canyon runs, had little to do with ancient trade routes. But here, too, I wanted to know if I could see the land as did the ancient runners. I also wanted to know if I could successfully photograph those scenes, as well as document the month-long adventure, as I ran.

But that proved to be the most difficult part—photographing myself in action. That necessitated my precomposing each scene, setting up my tripod, then running through the frame as I triggered the motordrive with a remote control. Still, I feared these photos might bear the unmistakable imprint of the setups

they were, unless I varied lenses to change the pace.

The camp scenes, on the other hand, came closer to capturing the reality and emotion of the thirty-three-day adventure simply because they were taken under more natural conditions. For instance, before hunkering down in each of my isolated camps, I set up my camera and tripod and focused on the camp scene. Then, say, if I broke down and cried because I was exhausted and lonely, or smiled because I still felt strong at the end of a 35-mile day, I'd press the remote and capture the moment.

One such scene was taken on Day 22, Sunday, May 10. In my notes I wrote: "Sundown overtakes me when I reach the first of four plunge pools I have to swim through in order to reach Tony's resupply camp at the head of the West Fork of Oak Creek. With the flashflood danger as high as it is, I cannot risk bivouacking below these pools. I strip down, stuff my clothes and camera gear into a WWII river bag, and shudder my way into the first, ink-black pool of water. I paddle and kick as furiously as I can in the bone-numbing water, my heart fibrillating wildly. I stumble and trudge into the next pool, confidently deluding myself I can stave off hypothermia. But I can barely keep my head from going under and blacking out. As I hyperventilate my way across pool number three, I think of my body being found floating face down the next morning; then I remember, the bodies of cold-water drowning victims usually sink. By pool four, I've got an 'ice cream headache,' I'm shivering uncontrollably, and my hands are so numb I can barely hold onto my river bag. If I manage to make it across this last pool, and Tony's not on the other side, I'll be too cold to get a fire started. Fortunately, I see a slot I can use to climb around the pool on its north side; I follow it, breathing like a dragon as I thread my way over a log jam. Near dark, I build a bivouac fire beneath a small overhang and call out Tony's name in hopes he set up camp within earshot. TONNYYY! TONNNYYY! No such luck. I drift off around ten o'clock, periodically waking up to stoke the fire throughout the long, lonely night."

I took a series of self-portraits at that bivouac when I first realized I'd have to spend another cold, hungry night in the wilderness alone. This photo, I felt, captured that feeling best.

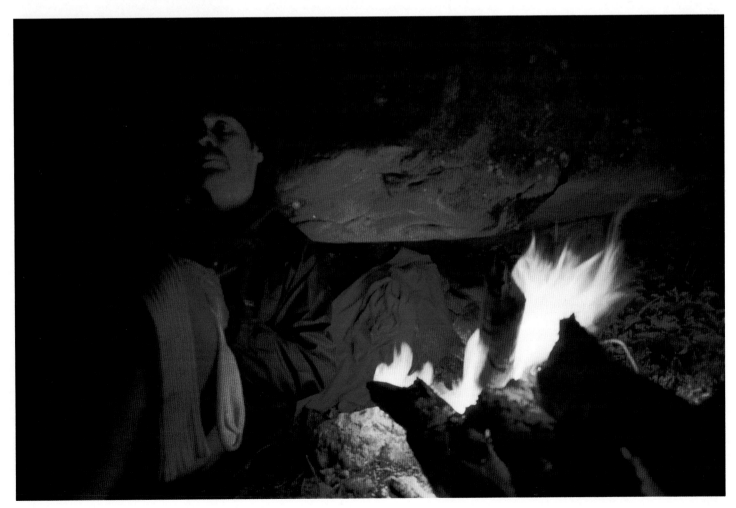

# LANDSCAPES

▼▼▼▼▼▼▼▼▼▼▼▼▼▼▼

## MYTHICAL KINGDOMS

▶

*When Dorothy sang "Somewhere Over the Rainbow" in the all-time classic movie* The Wizard of Oz, *she sang of a mystical kingdom that existed solely in the world of film and song. Perhaps more than any other natural wonder, the Grand Canyon of the Colorado River is about as close to the Land of Oz as most of us will get. When prospectors in the 1800s believed the canyon's paths were lined with gold, they streamed into the Grand Canyon hellbent on finding a pot of gold at the end of the rainbow. Most discovered, however, the only "color" the Canyon gave up was the mesmerizing hue it took on every time the sun eased in and out of its awesome depths. Those prospectors who stayed behind to guide tourists beneath its shimmering sandstone walls were held rapt by the canyon itself. Then, the Hopi Indians had recognized its mystical aura long before Garcia Lopez de Cardenas*

first "discovered" the Grand Canyon in 1540; to the Hopi, it represented the hole through which mankind originally emerged into the world.

More than any other scenic wonder, this canyon Oz has often defied verbal description. Photographers have captured on film what most writers failed to paint vividly with words. Consequently, the Grand Canyon has now been photographed so many different ways it's difficult to take a unique and exciting picture without embarking on an unusual adventure or by chancing upon stunning weather phenomena.

I was leading a group of pre-delinquent junior high school students on a ten-day "hood in the woods" course along the canyon's North Rim when we simply chanced upon a double-rainbow beaming into the headwaters of Crystal Creek. Taken more than fifteen years ago, this was my first photographic impression of the mythical kingdom of the Grand Canyon.

## ANCIENT PATH

▶

Long before El Camino del Diablo became the most deadly desert track in North America, members of the ancient Hohokam culture traveled across this appalling desert 150 miles to the Gulf of California. Archaeologists tell us they went to the gulf to gather shells that they fashioned into jewelry and traded with other tribes at the far ends of their extensive trade routes. The Papago Indians (Tohono O'Odham) later followed the ancient Hohokam routes to the gulf, combining vision-seeking quests with salt-collecting expeditions. Like their predecessors, the Papago traversed this ancient despoblado only to face, as their last major obstacle, El Gran Desierto—the largest and driest sand sea on the continent. Water

was virtually non-existent and, between tinajas, the *areneños*—"Sand People"—subsisted on a moisture-laden parasite called *hia tadk,* "dune root." But it was the few precious waterholes, more than the topography they traversed, that determined the Sand Papagos' course of travel across this fearsome desert; a series of ancient trails linked their life-saving tinajas and the areneños' one hope for survival.

Dating at least as far back as A.D. 1100, a handful of these pathways still can be seen heading across this modern despoblado, but they're so difficult to locate modern man has all but forgotten them. Bill Broyles and I were barreling across this outback on a two-lane track, returning from his epic rain gauge survey of southwest Arizona and frontier Sonora, when I noticed a single trail heading across the desert pavement. I feared it might be a vehicle track, but Bill was curious, too; so he slammed on the brakes in a hurricane of dust. There on the hard ground before us, unmarked by off-road vehicle tracks, was a pristine stretch of the ancient path, heading south across this vast expanse to the gulf. The sun had already set, turning the thin veil of clouds diaphanous pink. If I took time to set up my tripod, the moon would be enshrouded in clouds and I'd miss the picture; so I ran out across the desert, lay on my stomach and cradled the camera in my arms to take this photo of the ancient path.

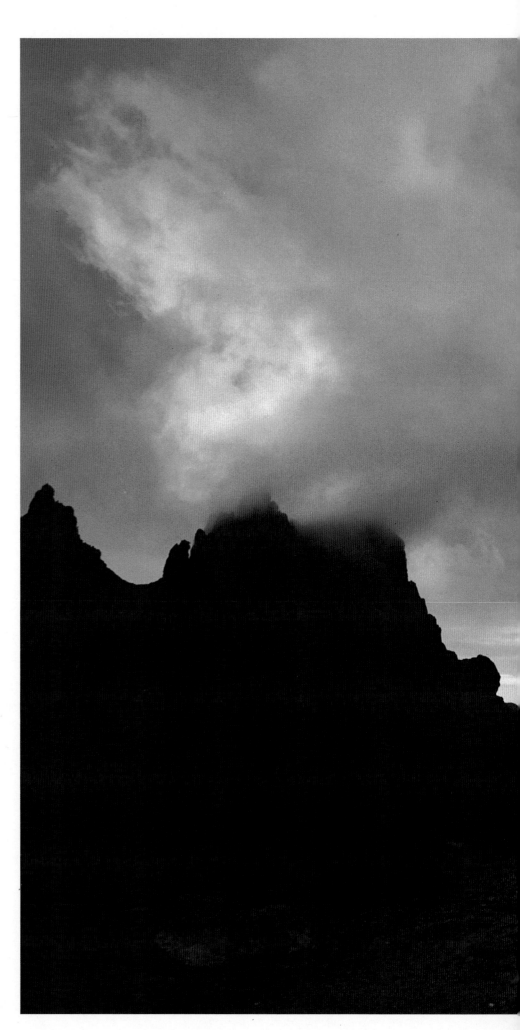

## HORNS OF THE DESERT

▶

Erupting out of La Posa Plain a fiery millennium ago, the Kofa Mountains now form a fossilized cauldron of imposing cliffs, deep-grooved gorges, and jagged pinnacles—and one of the most spectacular tracts of terrain in the western Sonoran desert. Rainy season in the Kofas is the time to capture the desert at its most dramatic.

More than a decade ago, I was hired to co-lead a week-long trek through the Kofas for divorced women. Hoping to show these mourning troops that chivalry was not dead, I rode in the back of the pickup truck with the gear. That's when I noticed clouds drifting over these desert ramparts, turning fire pink with the setting sun. I banged on the window and pleaded with the driver to stop so I could take a picture, but he would have none of it. Fortunately, he braked for a moment to ease over a boulder, and I braced my camera on the tailgate to take this picture before we resumed our head-jarring ride into the black Kofa interior.

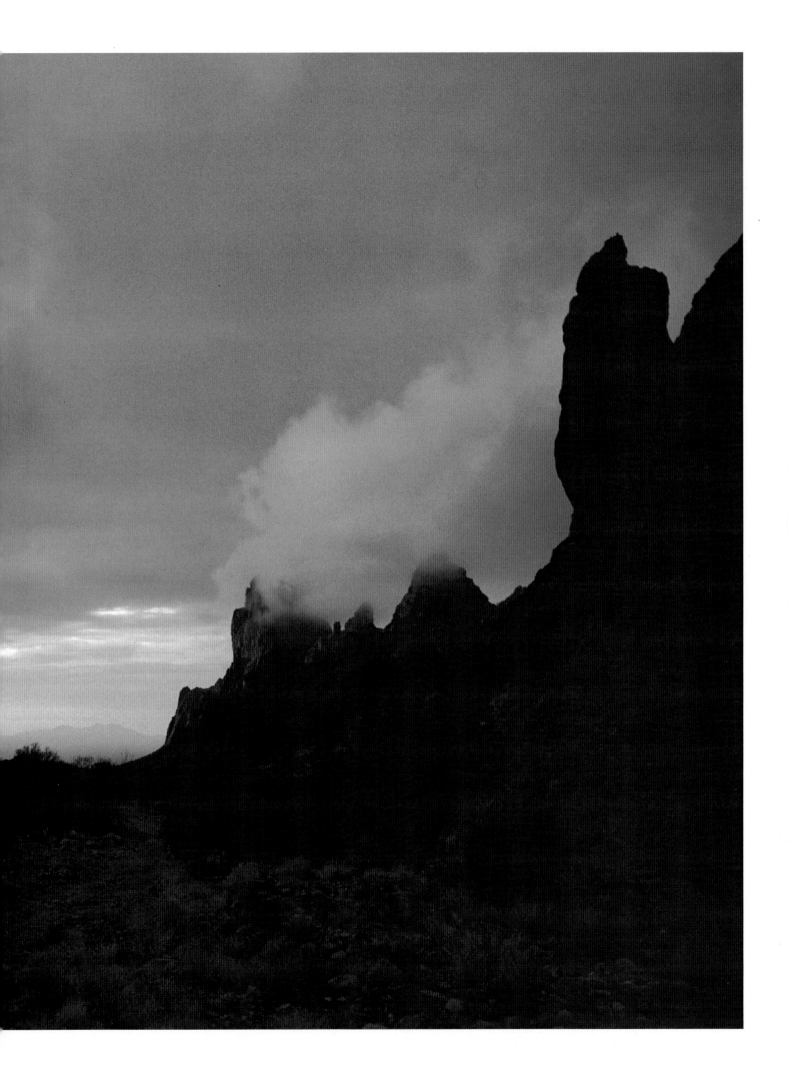

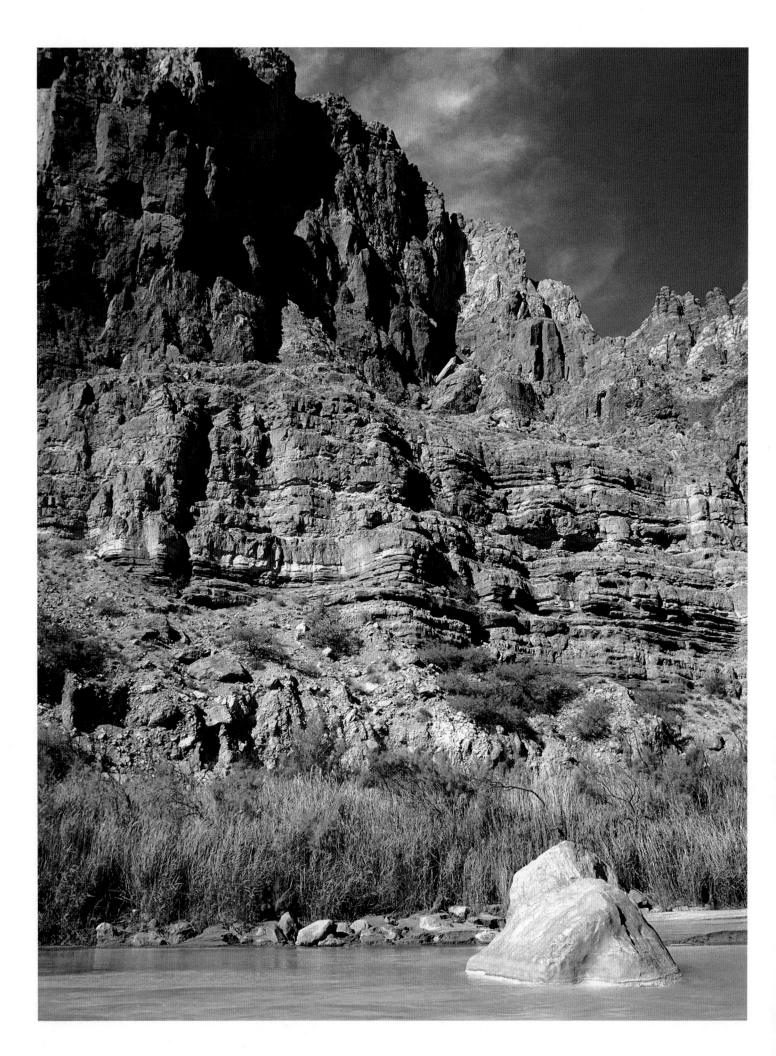

## LITTLE COLORADO RIVER GORGE

◀

Known as the *Colorado Chiquito* by Spanish missionary Francisco Tomas Garces in 1776, the Little Colorado River Gorge is one of the Grand Canyon's longest and deepest tributary canyons: nearly sixty miles long and 3,000 feet deep. The Hopi Indians first ventured partway through this Brobdingnagian chasm en route to their sacred salt mines in the heart of the Grand Canyon.

Few modern travelers, however, have followed in the Hopis' footsteps; fewer still have explored the length of the Little Colorado River Gorge, primarily because the only time to do so is during the hot dry season before summer monsoons or the cold damp months before winter rains. Either way necessitates carrying enough water—as well as food, bedding and camera gear—to reach the first dependable water source 35 miles downstream from the Gorge's entrance. Consequently, few pictures have been taken of the seldom traveled interior.

Two and a half days into my solo, week-long photographic trek through the Gorge, I finally reached Blue Springs in the dry June heat. My three one-gallon water jugs were empty, the temperature was pushing 115 degrees, and I was in serious need of a long drink. Little did I know, however, that the same carbonates that give Blue Springs its vivid color also made it nauseating to drink. And, no matter how I tried to mask its vile taste with powdered drinks, maintaining my two-and-a-half-gallon-a-day fluid requirements became a stomach-wrenching chore. Nonetheless, I couldn't resist taking another picture of its nauseating-blue waters as it pooled around this boulder near Salt Trail Canyon on Day 4.

## MONUMENT VALLEY

▶

Since the 1940s, Monument Valley has been the location for a variety of Hollywood movies, from John Ford's epic *How the West Was Won* to Clint Eastwood's hair-raising *The Eiger Sanction*. This Navajo Tribal Park also has seen its share of audacious television commercials and videos; everything from cars and typewriters to rock star Jon Bon Jovi have stood atop its cloud-piercing sandstone totems and mesas. All got there by helicopter.

Having survived one dangerous helicopter commercial in Monument Valley (page 113), Richard Nebeker and I were looking forward to a more mundane commercial that involved putting a golf green on the edge of a wide isolated mesa. The commercial went like this: Perched atop another mesa a mile away, Arnold Palmer would tee off and drive a golf ball across Monument Valley. Naturally, the ball would land on the green—testifying to his credibility as a spokesman for office products. Our job was to put the 17th hole atop Hunts Mesa's football-field–sized summit—and the only practical way to get there was via a Bell Jet Ranger helicopter. Compared to putting an executive desk atop the needle-thin Totem Pole, Rich and I knew this would be a safe and easy job.

We thought.

Foul weather or not, all commercials have strict budgets and narrow time constraints, so most producers don't like to see thousands of dollars standing around waiting for the weather to break if there's the remotest possibility of getting the shot. That's where the danger on this commercial suddenly reared its terrifying head—flying through blustery winter winds in a chopper overloaded with fuel, climbing gear, the director, producer, client and us "climb-

ers." Needless to say, with the helicopter bouncing around like tumbleweed, and the stall buzzer ringing in our ears like a self-destruct alarm, our first attempt to land was the most frightening chopper ride I'd ever been on—and I *trust* helicopters. Fortunately, the pilot's white knuckle flight convinced the producer we should turn back and try again the next morning. *The Twilight Zone* movie helicopter tragedy was fresh in everyone's mind at the time.

Loading our gear in the nerve-rattling, pre-dawn darkness, Rich and I agreed to walk away from this shoot if the powers that be insisted on flying in such dangerous winds; even with the money we were being paid, it wasn't worth the risk of crashing and burning. Fortunately, the winds lay dormant that morning as we skimmed across Monument Valley through utopian skies that, even before we landed, turned to pure magic. In fact, it looked more like afternoon light than a pre-dawn glow, and I wanted a picture before the skies turned a dismal wintry gray. We landed, unloaded our gear, signaled the chopper off. But before we rolled out the green carpet for Arnie, I ran to the mesa's western edge and lay down to take this picture while the light was still peaking.

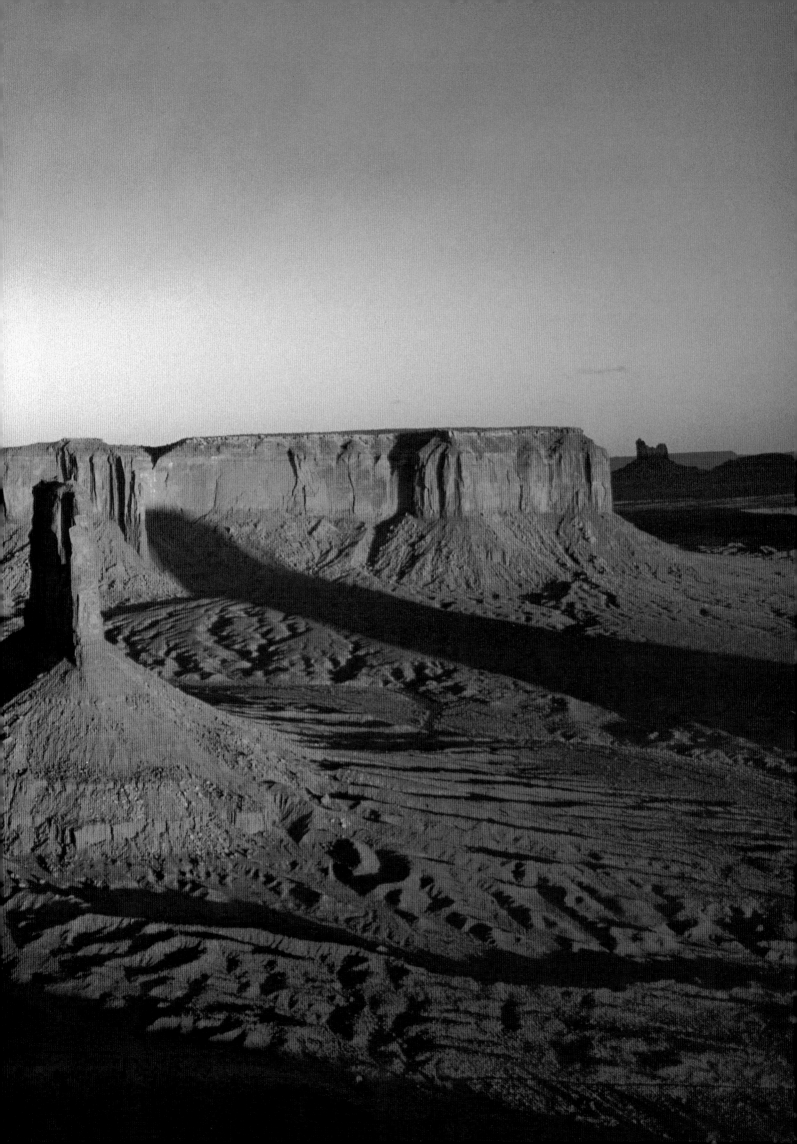

## DESIERTO PURGATORIO

▲

In *The Log from the Sea of Cortez,* John Steinbeck wrote: "It must have been a difficult task for those sturdy Jesuit fathers to impress the Indians of the Gulf. The very air here is miraculous, and the outlines of reality change with the moment. The sky sucks up the land and disgorges it. A dream hangs over the whole region, a brooding kind of hallucination."

Anthropologists estimate that the scorched slip of coastal desert where Gulf Indians like the Seri survive has a natural carrying capacity of barely one person per square mile. So it's easy to understand why the Jesuits didn't impress these hardy Indians, any more than the Spanish gold seekers or land barons did. In fact, the Seri fought off their relentless depredations, sometimes bluffing them with wooden rifles carved from stone-hard ironwood. And, to this day, some Seri of Desemboque continue to live on a high white dune overlooking the comings of both the desert and the sea.

I was camped on this dune with trader Jim Hills on my first trip to Seriland, when I took this twilight picture of what to me resembled Steinbeck's "brooding kind of hallucination."

## SAGUARO

▶

For centuries the Papago Indians harvested fruit from giant saguaro cacti and celebrated the occasion during their annual wine ceremony held at the end of the "saguaro ripe moon." For tourists, this strange plant, which can grow to forty feet and hold tons of water, has come to represent the desert Southwest. In reality, though, the Sonoran, Chihuahuan, Mojave and Great Basin deserts all converge in the region, and the elephantine saguaro represents only the Sonoran desert.

The days of this landmark cactus, however, are already numbered. Cattle, smog, developers and cactus rustlers gnaw like roaches on the flanks of the Sonoran desert's most magnificent saguaro forests. Every once in a while, though, nature calls in its own markers. Not long ago, a young Arizona man was reported using his shotgun to blow away a giant saguaro, limb by precious limb…but the mutilated saguaro fell on him, promptly killing him and creating what one writer described as the ultimate "cactus sandwich."

The days of these two gangly saguaro were also numbered, and before they toppled over and rotted on the floor of the desert, I was drawn to take an early morning portrait of them while en route to exploring a prehistoric waterhole in the Eagletail Mountains.

71

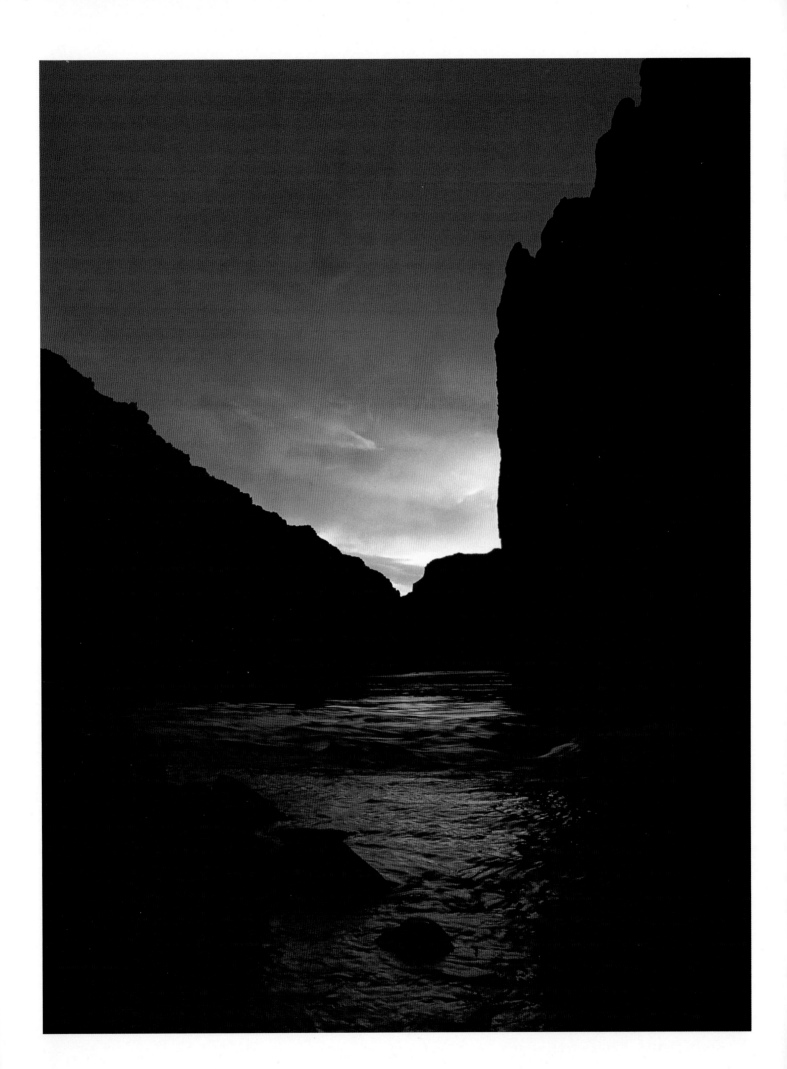

landscapes

## RIO COLORADO

◀

Many early river runners began their epic voyages through the canyons of the Green and Colorado rivers at Green River, Wyoming. But the headwaters of the Colorado River form on the west slope of the Continental Divide at 10,175-foot La Poudre Pass in Colorado's Rocky Mountains; en route to the Gulf of California some 1,400 miles downstream, the Colorado River descends more than 10,000 vertical feet and drains an area close to 244,000 square miles. The most famous segment of the Colorado River, however, is the 277-mile stretch that cut its way through the Grand Canyon.

Even before setting out to shoot my own photo essay of running this stretch of the Colorado River, I knew that other photographers had already done essays. So I decided I would photograph the river only during the hours of dawn and twilight; by doing so, I was hoping to show the enduring magic of a once wild river that was now harnessed to meet the peak power demands of Los Angeles and Phoenix. I also wanted to photograph before sunup and after sunset to see what the ephemeral ambient light did to this "red river." Of those efforts, this is one of my favorite pictures, taken at South Canyon near River Mile 31.

## BACK TO THE FUTURE III

▼

For the third installment of Steven Spielberg's *Back to the Future* trilogy, a drive-in movie theater was built incongruously in Monument Valley at the foot of Hunts Mesa.

En route back from the Arnold Palmer commercial shoot in the valley (page 67), I was hoping to get an aerial photo that showed this strange drive-in at the foot of a majestic mesa rising from the floor of the Great Basin desert. I got my chance not long after we struck Arnold Palmer's own preposterous set from atop Hunts Mesa, and the chopper pilot turned his ship into the nerve-wracking wind.

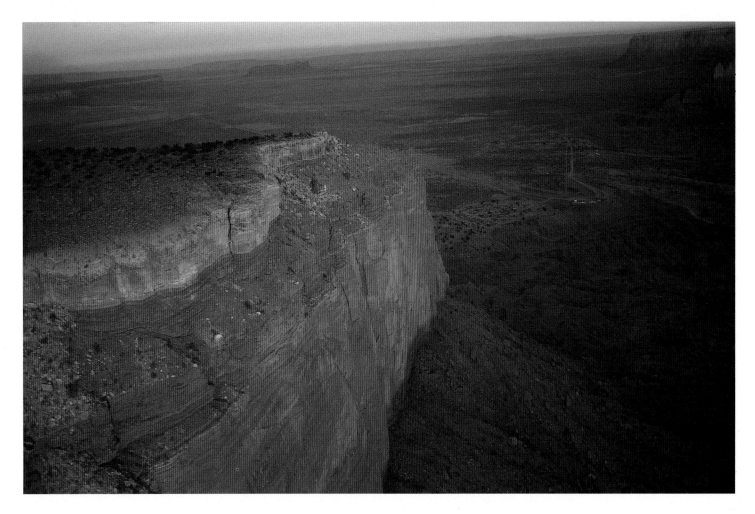

# WATER

▼▼▼▼▼▼▼▼▼▼▼▼▼▼

### CLEAR CREEK

▶

*Reportedly smaller than Chihuahua, Mexico's, Barranca del Cobre—"copper canyon"—and shallower than Oregon and Idaho's 7,900-foot-deep Hells Canyon, the Grand Canyon of the Colorado River still ranks as the most awesome single-canyon complex on earth. Comprising an estimated 2,000 square miles of northern Arizona, the Grand Canyon is two to eighteen miles wide, and at one point, nearly 6,000 feet deep.*

*Perhaps nowhere else is the relentless power of water erosion so striking as it is at the Grand Canyon. In a large part that's because between Lee's Ferry at River Mile 0 and Pierce Ferry on Lake Mead at Mile 279, more than seventy-seven major tributary drainages feed the Colorado River. Of these tributaries, none is more peculiar than Clear Creek. It is the one waterfall in the Grand Canyon that seemingly defies gravity by looping back up in the air.*

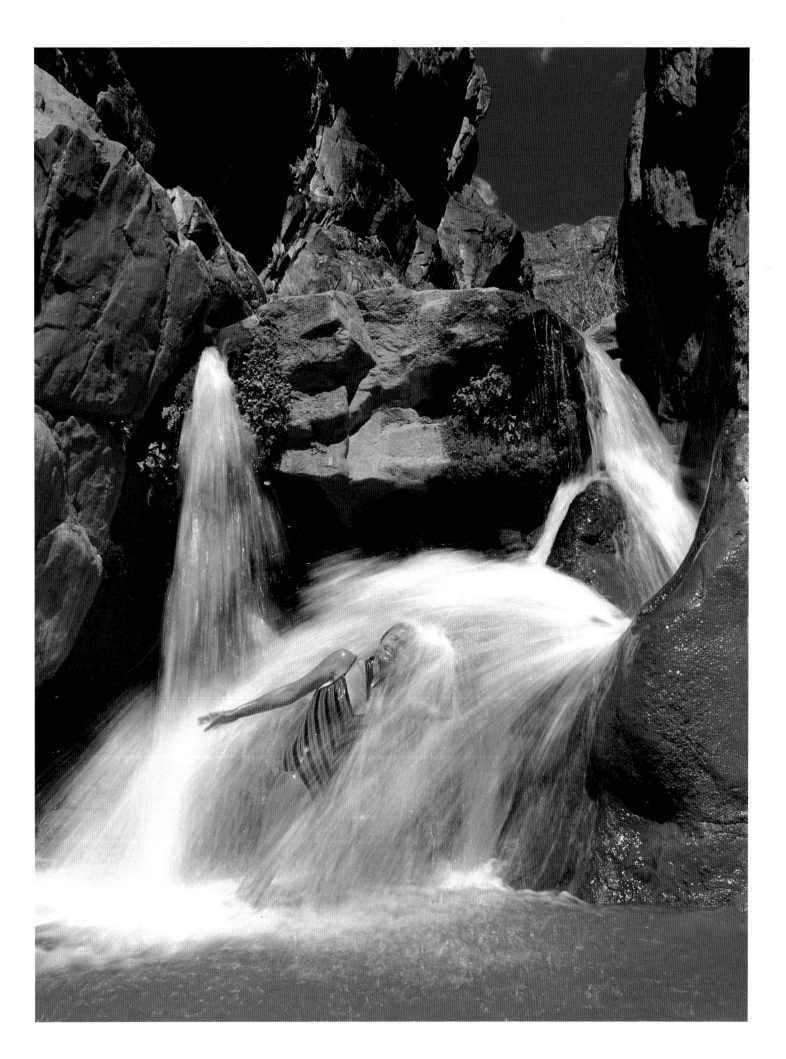

75

While photographing "Enduring Magic," I wanted to take a picture of boatwoman Louise Teal that showed her inescapable bond with the Colorado River and the seasonal arteries that sustain it. A self-proclaimed "boat hag," Louise has rowed no fewer than 85 trips through the Grand Canyon since her first one as a passenger in 1971, most of them for her employer Arizona Raft Adventures. That tallies up to 20,000 river miles and more than 1,100 days on the Colorado River!

Of the river's intriguing side canyons, I thought Clear Creek offered the best setting to fuse an image of this respected boatwoman with the timeless nature of water. On Day 6 of our 13-day river trip, I set up my tripod in the middle of Clear Creek to take this slow exposure of Louise Teal frolicking in it near River Mile 84.

## FIREBRAND RIVER

▼

When Spaniard Capt. Melchior Díaz first visited the lower Colorado River in 1541, he saw native people crossing it on "great rafts of agave...paddling with feet and carrying a lighted torch in their hands in order to keep fire on both sides." Accordingly, he named the river the Río del Tizón, "firebrand river."

I was canoeing the Colorado River south of Needles, California with some friends, when I started wondering what the river may have looked like when Díaz first saw it lit up with firebrands. I wasn't even considering whether or not I could take a picture hinting at such a spectacle, so I didn't give it any more thought until after we paddled into Topock Gorge to make camp. A campfire was out of the question, since we had a special permit just to camp overnight in the Havasu National Wildlife Refuge, so I turned in early hoping to photograph sunrise over the Colorado River.

I woke before daybreak and, from the high bluff where I'd perched my bedroll, watched the black river shimmering through the pre-dawn light below. I set up my tripod and took several wide-angle views of the scene, but I was looking for something more. As the sun erupted over the Mojave Mountains, the dark river turned an almost fluorescent orange; that's when I noticed the reflection of black reeds sticking out of the fiery water. I put on a long lens and made a picture of what to me looked like the Río del Tizón.

## RIVER WRANGLERS

▶

Fewer than 150 miles from metropolitan Los Angeles, the Forks of the Kern River ema-

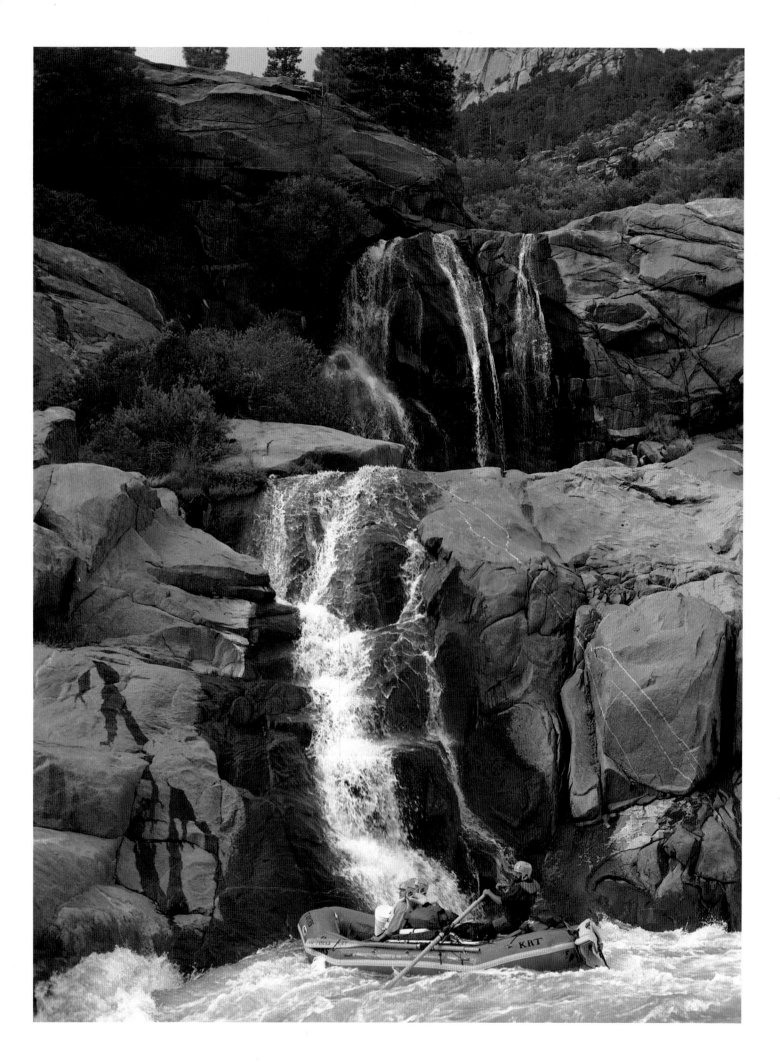

nates from the Golden Trout Wilderness near the crest of the Sierra Nevada Mountains. Dropping more than 80 feet per mile—compared to the seemingly benign eight feet per mile average the Colorado River makes in the Grand Canyon—the Forks of the Kern is the steepest commercially-guided river in North America. Faced with eighty-six rapids to negotiate in its cacophonous eighteen-mile stretch, most veteran Forks boatmen rightly consider it "one long rapid."

What also sets the Forks apart is access: the only way to reach the remote launch site for this wild, three-day plunge is by horse. That's where cowboys ride into this strange movie; using strings of pack mules and horses, wranglers provide the only means river runners have of hauling several tons of rafting equipment and provisions down the narrow, knee-wrenching trails penetrating the forest-cloaked interior of the Golden Trout Wilderness. That was just the hook I was looking for when I proposed a picture story on cowboys and whitewater rafting—"River Wranglers"—to the Black Star agency.

Because the Forks is such a "technical" river to navigate, photographing it can be more difficult than photographing Colorado Plateau rivers like the Colorado, Green and Yampa; you don't have the luxury of setting up above each major pool-drop rapid to photograph other boats as they tumble through. Consequently, most of your shooting, by necessity, is done from your boat. Photographing this adventure from a different point of view presents drawbacks.

Of the handful of places to pull ashore, the confluence of Needle Rock Falls and Needle Rock Rapids was my favorite. What intrigued me about this spot was the possibility of photographing a boat just as it reached the confluence—in that it might offer the illusion of having rafted down Needle Rock Falls. That's where I took this picture.

Postscript: Shortly afterwards, I "wrapped" my boat around a huge mid-stream boulder. The tremendous force of the river pummeling the submerged boat and waterproof camera boxes drowned several thousand dollars worth of camera gear. Fortunately, my film survived.

## JAVELINA SPRING

▲

During my month-long wilderness run from Mexico to Utah, I had my share of close calls. Barely two days into that 750-mile adventure, I was overtaken by a violent thunder and hailstorm while crossing the 9,796-foot Chiricahua Mountains. Darkness fell upon me, and I quickly became disoriented in the drifting fog and blowing sheets of ice. In my notes, I wrote: "My teeth chattering, I stop to build a bivouac fire before I succumb to hypothermia. I crumble up and burn my Chiricahua Peak, AZ map, but the precious chart isn't enough to ignite the small tipi of wet twigs. Shivering desperately, I pull out roll after roll of Kodachrome 200, but even the molten strips of burning film are not enough to ignite a fire in this storm. When I realize what's about to happen, I get up and run for my life across the dark, storm-battered mountaintop…"

Three days later, I almost died from the heat. From my notes of Day 6, Friday, April 24: "I'm sitting on the ragged crest of the Win-

chester Mountains in a torn pair of Levis. I'd worn them to protect my legs from vicious clusters of shin-daggers and manzanita I bushwhacked through from the Ellis Ranch to the 7,424-foot summit of Javelina Peak. But they are shredded and my legs are punctured and bloodied; worse, I'm out of water and slipping into heat prostration. So I continue scouring the desert grasslands far below for Javelina Spring; it's my only chance for survival. I plunge off the mountain, not knowing if I will find water in it or not. An hour later, my overheated body hisses in the cool, slimy water, and I come to grips with this hard country's wild environmental extremes."

At this point it was easy to forgo the picture possibilities of Javelina Spring; I was knocking on death's door and the last thing I wanted to do was try setting up a tripod. But I'd already run more than 150 miles with my stripped-down Gitzo, so I had to try one photo. I set the tripod on the edge of the stock pond and pre-

focused the camera. I only had one chance to get what I felt was the most important picture—breaching out of Javelina Spring. So I set the self-timer, and submerged myself. I could feel water spiders swimming around my face and ears as I counted to ten, but at the last moment I decided to surface at the count of nine. Fortunately, I hit it lucky.

## BLACK POOL

▼

Kathleen Pecuch and *Arizona Highways* magazine editor Bob Farrell had gone with me into the West Fork of Oak Creek with the hopes of exploring it end-to-end for the book I was photographing at the time. We knew the canyon was roughly twelve miles long, and that it cleaved the impregnable buttresses of the densely-wooded, seven-thousand-foot high

Coconino Plateau. What we didn't know, however, was how many cold plunge pools we'd have to swim through before we could resume trekking again. But then, that's what lured us into this mysterious canyon to begin with. From my notes at the time:

"We reach the first plunge pool late in the afternoon of the first day; it's more than seventy feet across, a dozen feet wide, and we're not sure how deep. But in this shaded abyss, it looks more like a well of icy black ink. There is no discussion as to who will swim across first: I am the "expedition photographer," Bob is the copy editor, and Kathleen is the triathlete. So Bob and I squat like fat pigeons on a high roost while Kathleen grits her teeth and plunges in to test the waters."

What struck me about this particular photo, of the series I took, was that Kathleen's clean smile was the only bright spot in what looked like an oil slick.

# CONQUISTADOR AISLE

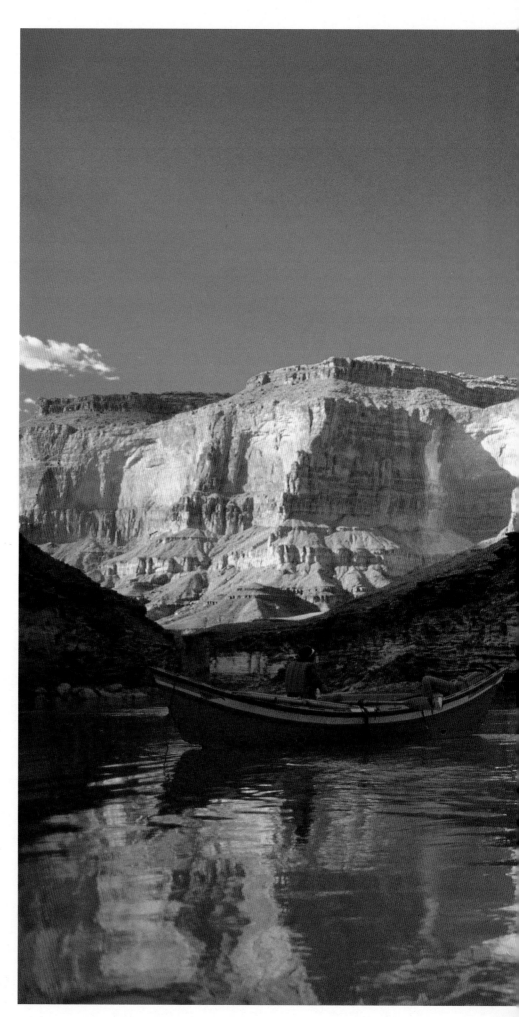

▶

Even before prospector James White and Major John Wesley Powell headed down the Colorado River toward its fearsome Cataracts during the 1860s, Lt. Joseph C. Ives had struggled upstream toward such unforeseen obstacles. Only Ives didn't try to navigate the Colorado River on a log raft, as many believe White did, or in a small wooden boat as Powell did. Ives would attempt the first upstream run of the Colorado River in a fifty-eight-foot-long steamboat called the *Explorer.* Assigned by the War Department, Lt. Ives' mission was to search out the head of steamboat navigation so military forts along the river could be re-supplied by paddle wheelers.

However, when the steel-hulled *Explorer* hit a submerged boulder in Black Canyon, Ives' 1858 expedition was essentially over. Said Ives: "The concussion was so violent that men near the bow were thrown overboard...and it was expected the boat would fill and sink."

Located above the Middle Granite Gorge nearly 200 miles upstream from Black Canyon, Conquistador Aisle was reportedly named after Colorado River explorers like Lt. Ives. What struck me about Conquistador Aisle was not just that modern river runners can now drift peaceably along a stretch of river that once struck fear and wonder in the earliest explorers, but I especially liked the way the river mirrored the image of late afternoon light refracting off sweeping walls of red limestone. So I took this picture of boatman Renny Sumner near River Mile 121.

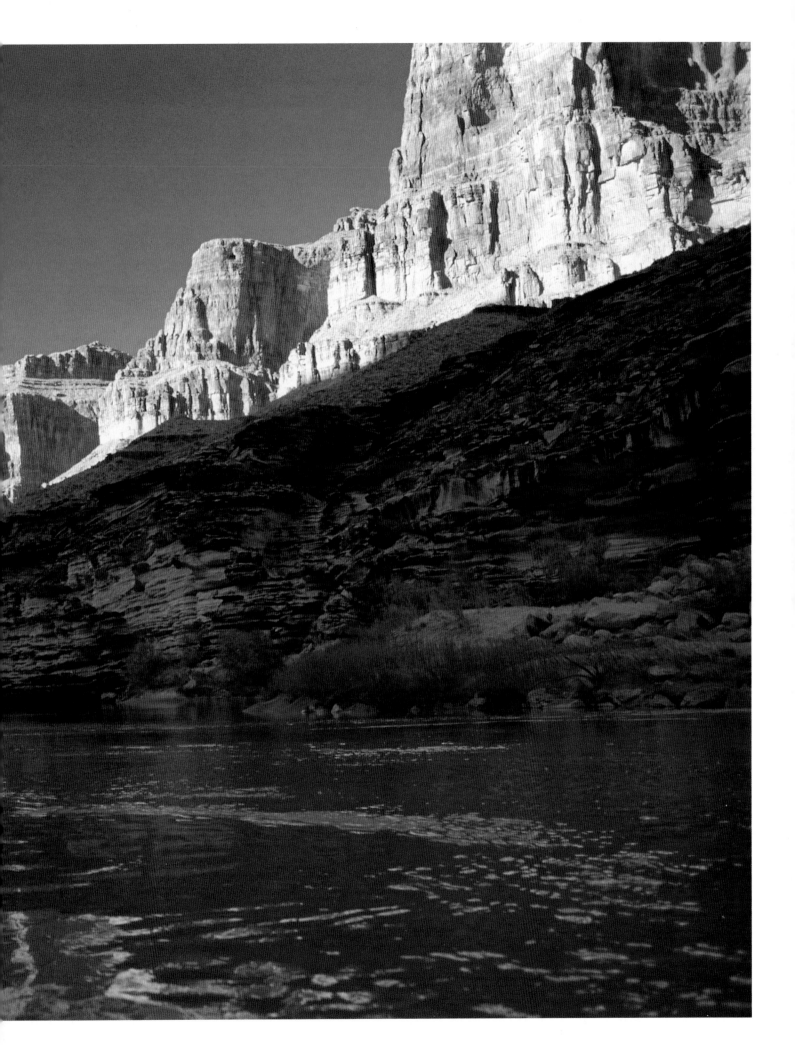

## LAVA FALLS

▶

Of the 160 rapids that have thrilled Grand Canyon river runners since the days of Major Powell, Lava Falls remains the one great equalizer that must be reckoned with; it is a legendary "big drop," the steepest in North America. When I was outlining my "Enduring Magic" essay, I wanted a photo of Lava Falls that not only captured the action, but also showed the 37-foot drop the rapid makes.

However, by the time all the boatmen and -women had scouted the rapids, and discussed the pros and cons of each of their runs, Lava Falls was cast in shadow, and the light was fading fast. I had no choice but to switch to a faster film before scrambling down to a rock near river's edge; from this frothy perch, I was able to shoot upstream as boatwoman Ginger Henchman rowed into the maelstrom with a screaming passenger on her bow.

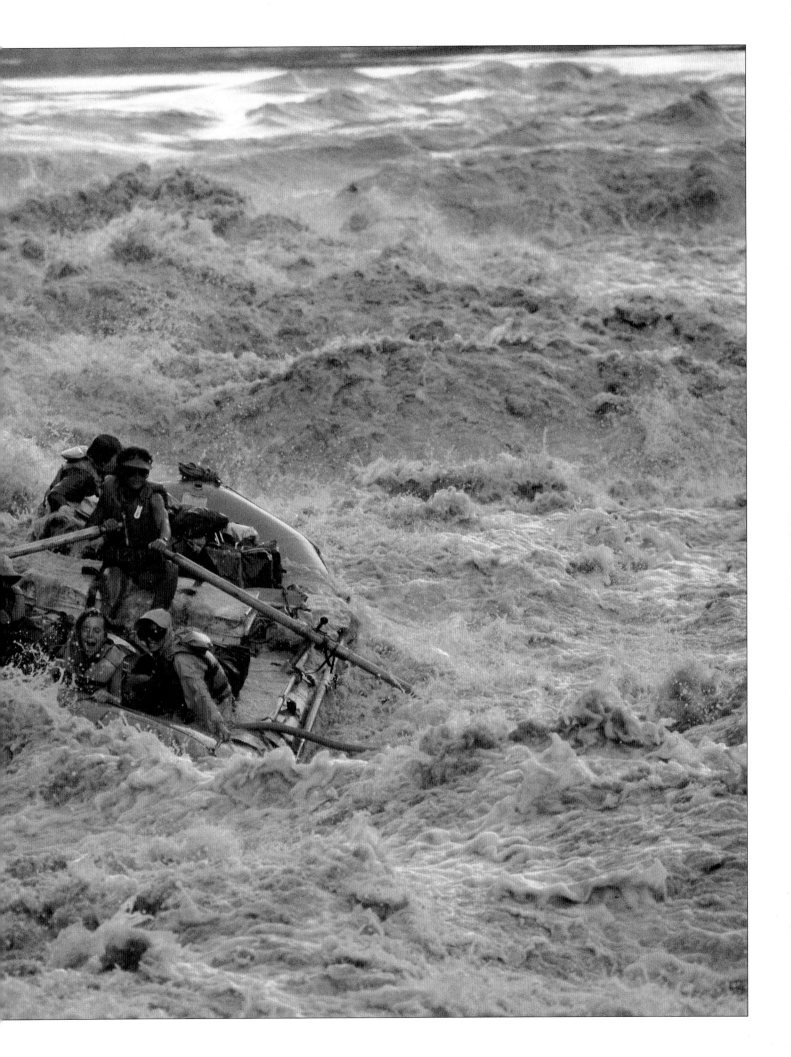

# DANGER

## ROUGHSTOCK

▶

*One-time roughstock rider turned Hollywood actor Slim Pickens took his most famous ride on a nuclear bomb in the Peter Sellers movie* Dr. Strangelove. *When asked why he went from rodeo cowboying to movie cowpokin', the late great character actor said: "Ain't never had one dang camera run over me."*

*...And Pickens' words sum up perfectly the risks roughstock riders face each and every time they climb on the back of a writhing, four-legged bomb lit with an eight-second fuse. Bones get broken, and heads get stomped on—usually those of the cowboys. And roughstock competitors are notorious for riding with injuries that would sideline most other professional athletes.*

*Today, however, a growing number of roughstock riders try to prevent such injuries by taping up their ankles, knees, and elbows, so if they get tossed before the eight-second bell, as this bareback rider did, they can usually get up, brush off the dust, and ride again. Usually. This photo was taken from behind the chutes at the Fiesta de los Vaqueros Rodeo in Tucson.*

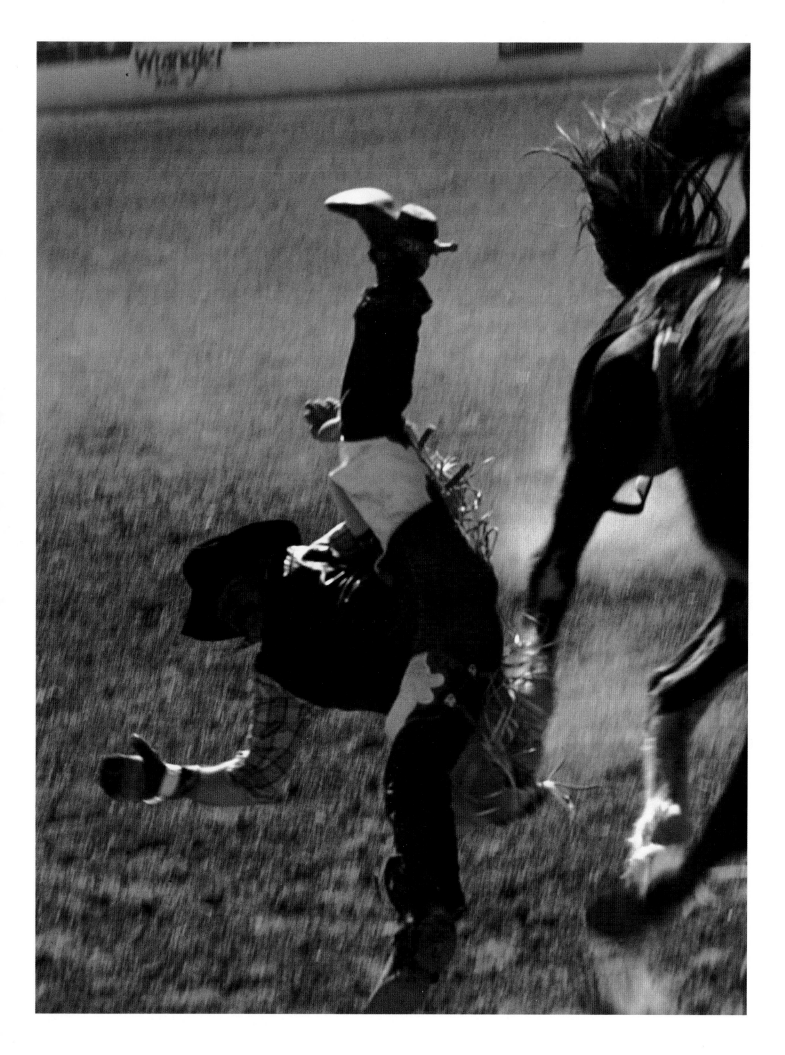

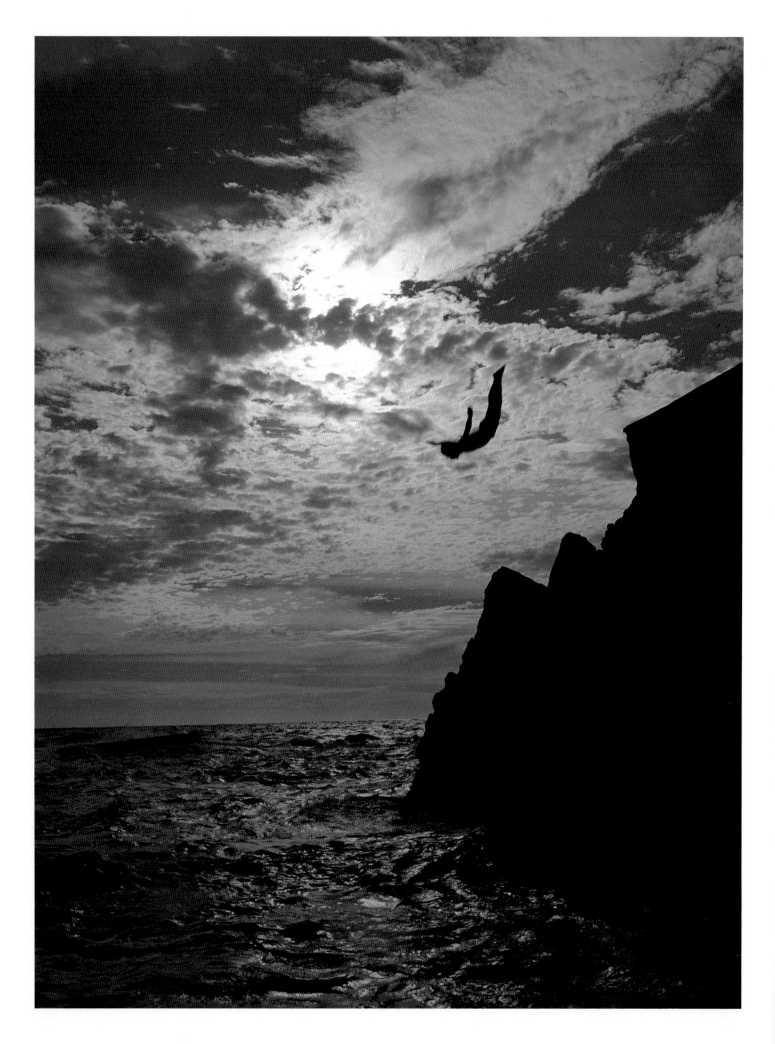

danger

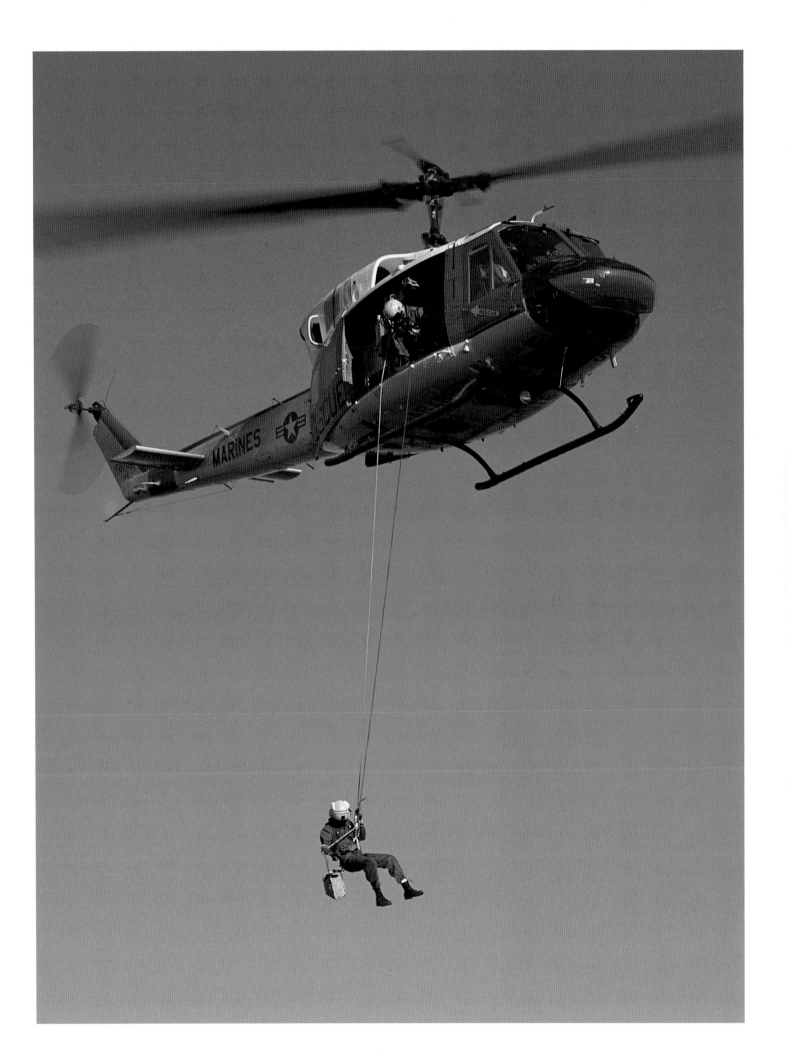

## CLIFF DIVER

◄ ◄

When I was sixteen, I ran away to Hawaii to become a big-wave surfer. However, by the time I hit the streets of Oahu I was penniless, and any visions I had of following the footsteps of legendary surf king Duke Kahanamoku were quickly dispelled my first night on the island. I watched a sailor, drenched in blood, stumble out of a Waikiki bar after being stabbed. Worse, I'd been told I wasn't old enough to get a work permit to cut pineapples on Kauai.

I wasn't sure where to turn, so I slept on the beach that night, under a catamaran, using my suitcase full of brand new surfer T-shirts as a pillow. But the next morning, a Hawaiian named Sabu woke me up. "Hey, *haole,* what you doing sleeping dere?" I rubbed the sand out of my eyes and told the long-haired islander my dream of becoming a big-wave surfer, but Sabu couldn't believe such a young haole, "white guy," would leave the mainland without any money or a plane ticket home. I told him I wasn't going home. So Sabu took me to meet his friends, a group of Hawaiian beachboys who, I soon learned, sang Don Ho songs for haole girls at night and dove for coins by day. Whether they felt sorry for me, or actually liked me, I wasn't sure. But they fed me and let me stay in their beachside digs, telling me "Ain't no big t'ing, brodha."

For them, it wasn't. But I knew I wasn't part of the fold until, some weeks later, they took me down to the Ala Moana boat harbor to dive for coins. Haoles weren't allowed to do that, but because I was with them I got to dive for quarters, half dollars and silver dollars tourists threw off luxury liners. When the diving was over that morning, everybody pooled their money and bought steamed fish, rice and poi from the lunch wagon that waited nearby. That would do, I soon learned, until the next ship came in—or one of us met the next rich haole girl. I never rode Waimea's thirty footers, but after a summer of surfing Oahu's south shore and playing beachboy, I eventually found

my way back to the mainland and high school.

I'd forgotten about the Ala Moana boat harbor scene until years later, when I went to Mazatlán to shoot the "Spring Break" story. I caught a local bus south from the zona dorada to check out the cliff divers. Here, near the very point where Spanish conquistador Nuño de Guzmán founded Mazatlán, "place of the deer," was a variation on the Ala Moana boat harbor scene. Only, instead of native Mexicans diving for meager coins tossed from ships, cliff divers like Roberto Jauregui Villegas were making bold, treacherous dives into the rocky waters of the Pacific for busloads of video- and camera-toting tourists who paid $10, plus tips, for each dive. Not that Roberto didn't know another trade—on the contrary. Born in Guadalajara, Roberto made "big money" working as a carpenter in Los Angeles. But the sea and family called him home, and he returned to Mazatlán to continue diving, as he is here, from the same dangerous cliff he's survived for the last 20 years.

## HELICOPTER RAPPEL

◄

During the summer of 1986, Rescue-1 performed a daring air rescue—perhaps its most dangerous to date. The Marine Corps Air Station, Yuma, received a call from the National Park Service at 0300 hours that a teenage boy and his would-be rescuer, Ranger Pete Dalton, were stranded midway up a thousand-foot cliff below Hoover Dam. It was dark and the thundering waters of the Colorado River howled through the depths of Black Canyon. According to one published account: "The helicopter, piloted by Capt. Jim Silliman…hovered over the site as Navy Corpsman HM 2 Michael J. Lebrun…rappeled from the craft to the ledge to secure Dalton and Hopfer [the teenager] with ropes…Lebrun attached Hopfer to himself with a rope and attached the ranger to another rope. Lebrun then wrapped his legs

around the two people. The helicopter, with its blades coming within three feet of the cliff, backed away from the spot at 5:56 a.m. as the three dangled 125 feet below."

Because it's far too dangerous to land in many cliff, canyon and mountain rescues, Rescue-1 frequently practices helicopter rappels to train for such life-threatening scenarios. Pictured here: Navy Corpsman Noel Ramirez is the crew's paramedic, so he must face the hazards of rappeling from a stationary helicopter already stressed to the limit by hovering in place.

## HIGH WIRE ACT

▶

I was barreling south out of Mexicali across the San Felipe Desert, weaving down a strip of cratered blacktop that looked like it had taken heavy mortar fire. I was en route to climb— and photograph—10,154-foot *Picacho del Diablo,* "Peak of the Devil," for a book. It's Baja's highest and, some think, most notorious mountain. So, between the driving and my anxieties about the remote climb ahead, I didn't notice the four men dangling from a 760-KV transmission line until I was a half mile past. Then, the red light suddenly went on. The men were dangling several hundred feet off the ground and, unlike the Flying Wallendas, working without a net! I slammed on the brakes and slid into a wide U-turn, hoping to photograph this dangerous high wire act before they broke for lunch—or simply broke their necks.

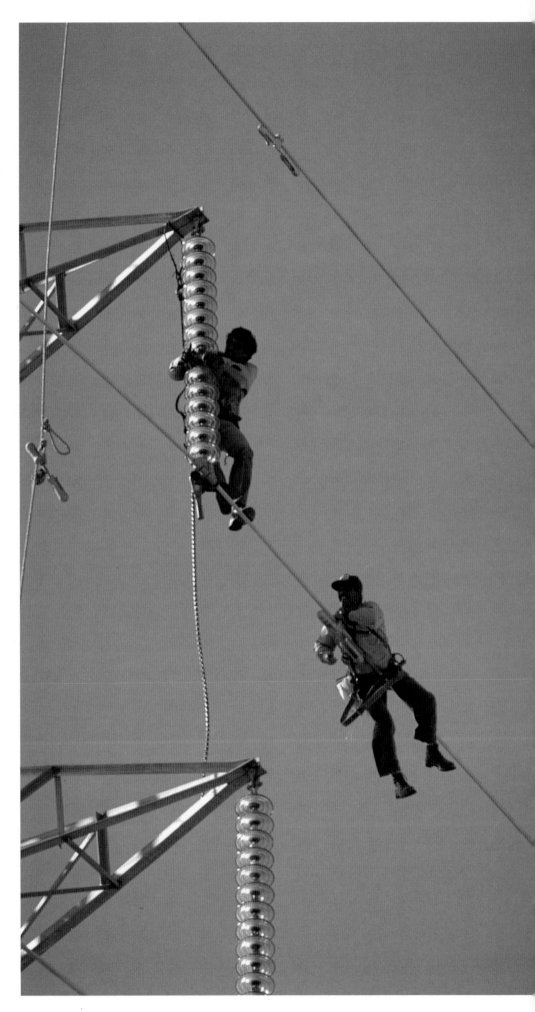

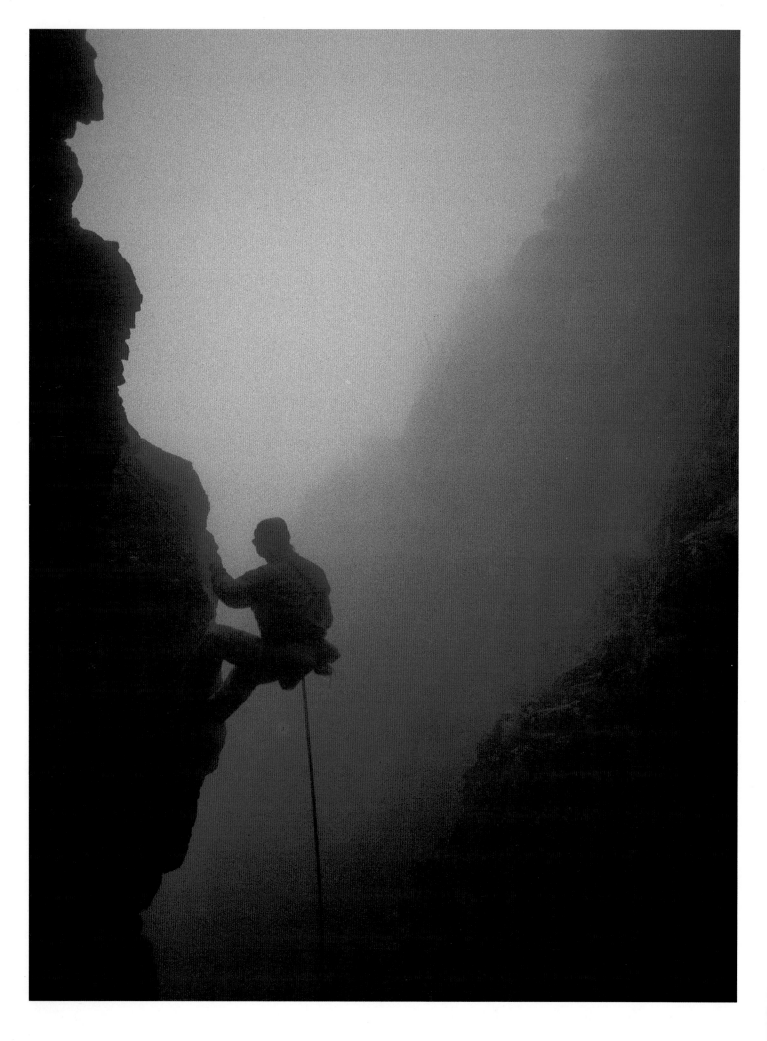

danger

## DESCENT INTO THE MIST

◄

The American Alpine Club publishes an annual report called *Accidents in North American Mountaineering,* analyzing factors contributing to reported climbing accidents, and how those accidents might have been averted. Statistics show that roughly half of all climbing accidents take place during the ascent, while the other half happen during the descent. Of the latter, many accidents are attributed to rappeling. In fact, the pages of climbing history are tragically littered with the bodies of world-famous climbers who for one distracted moment clipped or unclipped the wrong carabinier and fell to their deaths.

That was my main concern when I took the summit photo, "Burning Daylight," on page 20: how do Randy Mulkey and I get off this peak in the dark, without making a simple, yet fatal mistake? Slowly, double-checking each other's knots and carabiniers with a flashlight, Randy carefully rappeled into the dark, swirling mist, while I took this photo from a ledge before following him down.

## THUNDER RIVER

▼

Little more than a half mile long, Thunder River has the distinction of being one of the shortest rivers in the world. It spews out of a subterranean aquifer below the North Rim of the Grand Canyon, tumbles and roars down 1,200 vertical feet into Tapeats Creek, forming the most breath-taking cascade in the Grand Canyon. During the spring run-off, it also forms a formidable barrier to inner-canyon travel in the region.

After considering several possible routes for my last run through the Grand Canyon, a 250-miler below the North Rim, I knew I wanted to end the adventure at Thunder River. However, one of primary concerns was, assuming I actually completed the week-long run, how would I cross Thunder River in late April or early May when it would be roaring with snow melt? If need be, I thought, a tyrolean traverse could be rigged up by my support crew to bring me across.

To see how practical that option was, Robert Himber and I trekked eight miles into Thunder River and set up a tyrolean traverse. Fortunately, when I actually reached the end of my North Rim run eight months after our recon, I found another way to get across Thunder River. And my support crew was spared the obvious risks of setting up such a dangerous rope maneuver.

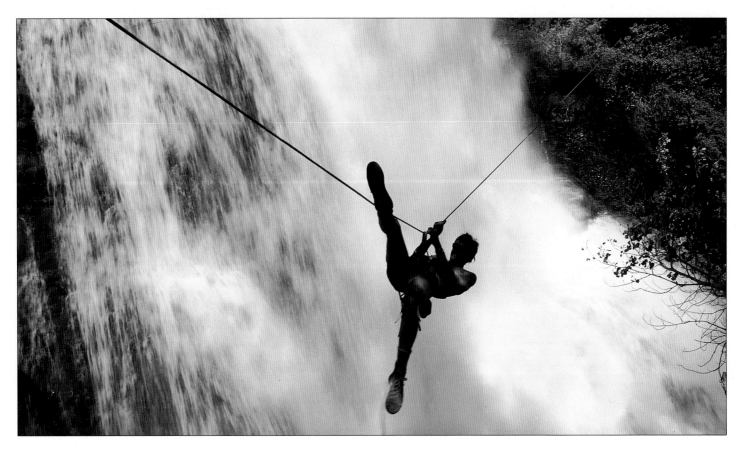

danger

## GHOST RIDER

◄

Not long after I began photographing *Path of Fire,* I discovered I'd made friends on both sides of the U.S./Mexico border. I tried to avoid it, in hopes of maintaining my objectivity, but under the stress of life-or-death border crossings and prolonged low-level flying, bonds were formed. Ironically, I became friends with some of the men I'd crossed the desert with— as well as some of the men who hunted them.

One friendship that formed north of the line was with Border Patrol Pilot David Roberson. Born in Comanche, Texas, Dave first learned to cut sign along the Rio Grande between Del Rio and El Paso, but he always had the wild blue yonder in his eyes. And after logging 1,500 hours of flight time, he became Supervisory Pilot for the Yuma Sector of the U.S. Border Patrol. That's when Dave first teamed up with Joe McCraw. Working a trail together during the killing season between April and October, Roberson and McCraw tracked with an almost missionary zeal—one from the air, the other on the ground. They both knew that, once they started on a set of tracks, they had so much ground to cover in so little time, before the

desert swallowed another victim alive. That's what made them both law enforcement heroes.

Tragically, Dave died doing what he loved best, flying low enough through the whirling mirage of saguaro, greasewood and palo verde trees to track from the air. A 23-year veteran with 9,000 hours of flight time, Dave once told me, "It gives you a good feeling to find somebody down there who's really in trouble." Then, that's what happened to Dave Roberson; he got into trouble and, unlike the men he saved, there was no one to catch him when he went down. Sources close to Dave said the fateful morning was so calm, and that Dave flew such perfect circles, he flew back into his own prop wash. The cyclone of wind flipped his plane, but Dave was too low to pull out before he crashed and burned. And now, every time I hear a Super Cub flying overhead, I can't help but think of my friend Dave up there, ghost riding in the sky.

## RIO DE LAS BALSAS

▶

It's difficult to pinpoint exactly when the upper Salt River was first run, but from the name Coronado's men first gave the river in 1540, Río de la Balsas, "river of rafts," it's safe to assume the Spanish conquistadors built reed rafts in order to cross the river during their fevered quest to locate the fabled Seven Cities of Cibola. The first non-Indian to travel the length of the Upper Salt was mountain man James Ohio Pattie. But Pattie's diary provides little insight into the difficulties he and a party of French trappers may have encountered along the upper Salt during the winter of 1826. February runoff usually is very low, and Pattie might have enjoyed easy going and balmy winter temperatures. However, if rain fell on the snowpack, as it did on February 15, 1980, Pattie could have been trapping up and down a cauldron of snowmelt that, in 1980 for instance, peaked at 41,200 cubic feet per second. In modern rafting terms, that's virtually unrunnable by all but the most seasoned "hair boaters."

That's what sets Arizona's upper Salt River apart from most other rivers of the West. It is undammed and thus untamed. With the Salt's headwaters formed in the sub-alpine forests of 11,590-foot Mt. Baldy, boatmen must adapt to its seasonal—and daily—fluctuations as it boils down 10,000 vertical feet through the modern terra incognita of Salt River Canyon.

Bad day at Black Rock. Here Prescott College rafting student Dave Duckett, unprepared for such turbulent runoff, gets hammered in Black Rock Rapid, as former passenger Anne Taber goes down for what was nearly her final count.

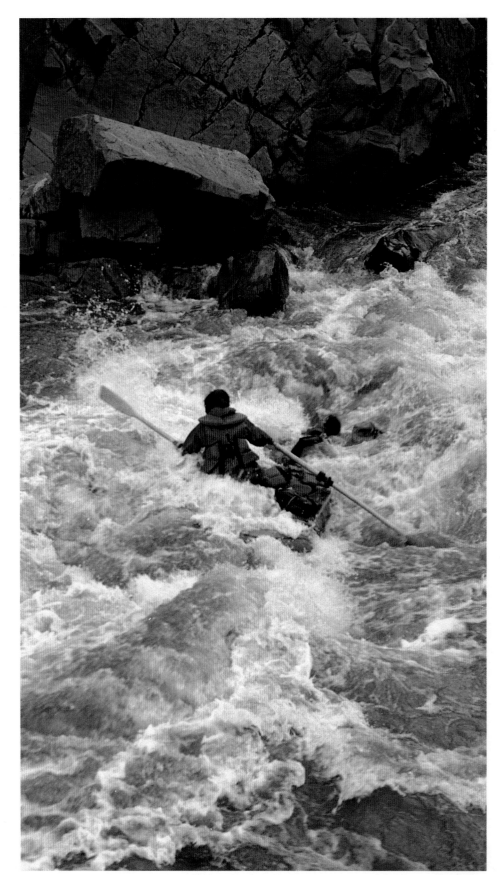

# DEATH IN THE DESERT

▼

In 1906, southwest researcher W.J. McGee presented his landmark paper, "Desert Thirst as a Disease" to a group of Missouri doctors; the paper concerned the incredible ordeal of Mexican prospector Pablo Valencia who got disoriented while traversing the Camino del Diablo the previous August. For eight days and nights, McGee reported after he'd found him, Pablo fought his way across 100 to 150 miles of burning Arizona desert. The man had little more to drink than his first day's ration of water, his urine, and the moisture sucked from a scorpion and some insects. It was, McGee proclaimed "a desert record without parallel known to me."

However, when Pablo Valencia crawled back to McGee's camp near Tinajas Altas on Wednesday morning, August 23, McGee reported: "We soon found him deaf to all but loud sounds, and so blind as to distinguish nothing save light and dark. The mucous membrane lining mouth and throat was shriveled, cracked and blackened, and his tongue shrunken to a mere bunch of black integument. His respiration was slow, spasmodic, and accomplished by a deep guttural moaning or roaring—the sound that had awakened us a quarter of a mile away…The eight day siege lost him 35 to 40 pounds (or 25 percent) of his weight, chiefly through evaporation from skin membrane." That Pablo Valencia survived had as much to do with his unflagging will to live as with McGee's own tireless efforts to save him.

Pablo Valencia's case also foreshadowed another fact. Modern desert travelers in this region don't die in the middle of this unforgiving desert; most often, they go down within sight, or earshot, of their goal—as was the case of this man. When Bill Broyles and I made this horrible find on July 5, 1990, at 1:30 p.m., the man's location and tracks indicated his route out of Mexico crossed the Lechuguila Desert by paralleling the northern end of El Camino del Diablo to the east. At thirty-five miles—from Mexico's Highway 2 to Interstate 8—his route was short compared to the 50-, 75-, and 120-mile-long desert routes to the east. Yet, already 27 miles out, carrying no less than a gallon of water, he got caught by a record 120-degree heat wave, and lay down to die under this palo verde tree, only eight miles short of the Mohawk Canal.

We found this man's death especially tragic for a number of reasons: Bill has such a great affinity for this desert, and its history, that he retraced Pablo Valencia's epic route—almost dying in the process, himself—and later wrote his own classic report called "The Ordeal of Pablo Valencia." Having crossed this desert myself to document the heroic treks of men like these, I was especially troubled because this man went down right beside a modern Border Patrol drag road! Not only had the Border Patrol failed to track him across this desert, but they didn't even see his body five feet off the road. But then, this man didn't have

trackers like Roberson and McCraw cutting his sign: Dave had died in the desert a year earlier and McCraw, like all Border Patrol agents, had already faced mandatory retirement at age 55—"just at the prime time," Joe said, "the officer could be doing the service a whole lot of good." In this case, old line trackers like Roberson and McCraw both could have done "a whole lot of good." Having photographed the skeletal remains of many Mexican citizens in this desert, it was the first time I faced such gruesome remains: the grim truth of "desert thirst as a disease," and I prayed to God I was taking the best picture I could under the circumstances so that it does somebody some good.

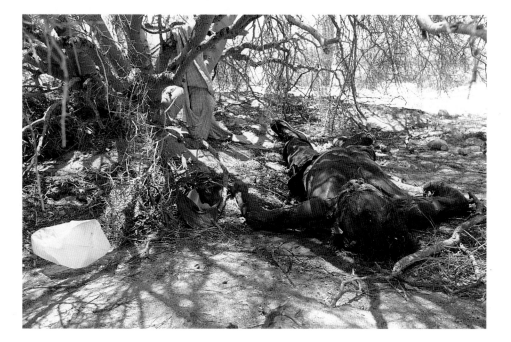

# PEOPLE IN THE LANDSCAPE

▼▼▼▼▼▼▼▼▼▼

## THE LOST WORLD OF SHIVA TEMPLE

▶

*Floating in the heart of the Grand Canyon, the 7,646-foot mesa-topped summit of Shiva Temple has been seemingly cut off from the rest of the world by 20,000 years of erosion. Yet, it was for just that reason this "lost forest" received its most publicized and controversial ascent on September 16, 1937. Scientists believed "that animal life on isolated mesas might have evolved into forms distinct from those on the [canyon's north and south] rim," so the American Museum of Natural History mounted expeditionary forces equipped as if they were about to tackle a Himalayan giant. Musing at the possibilities, the press anxiously covered the expedition to "The Lost World of Shiva Temple." A September 11, 1937 Associated Press dispatch captured the essence of the drama many hoped would unfold: "Two scientific parties waited near the brink of the Grand Canyon tonight, eager to scale unexplored Shiva Temple, the "lost forest" separated from the mainland for untold*

centuries, in search of animal species dating from the last glacier age." Glacial Epoch. The very time period evoked images of hairy beasts still roaming a pre-historic Canyon frontier.

The ballyhooed expedition to Shiva, however, was a bust. By following an ancient Pueblo Indian route to this summit, Grand Canyon explorer Emery Kolb climbed the temple twice in the weeks preceding the Shiva Temple Expedition—thus eclipsing their claim of a first ascent. Secondly, after the grant-fat expedition finally scaled Shiva and studied its animal life, they reported: "As this article goes to press [a] comparison has been made and reveals no noticeable difference between the animals of Shiva and those of the rim."

On assignment for *Travel & Leisure* to shoot a cover for their Grand Canyon issue, I thought "the lost world of Shiva Temple" offered the most striking possibilities. Picture Editor Hazel Hammond and I agreed the photo needed to pull the viewer into the cover and thought a person peering over the very edge of the Canyon might be ideal. The best location to do that, I thought, was the exposed southwest corner of Shiva Temple because of its isolated position within the Grand Canyon.

Grand Canyon climber and boatman George Bain was hired as the model and, together with climbing partner Craig Newman, we followed the rugged, day-long route of the 1937 expedition off the North Rim out to the summit of Shiva. Once at the site of their historic camp, we headed through the "lost forest" to set up an airy camp on the opposite side.

It was a surprisingly cloudless December day, and as the afternoon light peaked, I photographed George peering over the very edge of Shiva into the yawning abyss thousands of feet below. The composition was unnerving. In fact, as a climber, I found it more unsettling to watch—and photograph—someone else scrambling along this precipice than if I'd done

it myself. I offered to tie George into a climbing rope, but he assured me he was more comfortable without one. We tried a variety of situations throughout the two balmy days we danced with winter light atop Shiva, but the picture I composed that first afternoon is the one that made the cover.

## REDWALL CAVERN

▶

Like most modern visitors to the mesas and canyons of the 150,000-square-mile Colorado Plateau, Major John Wesley Powell was awestruck by the scenery when he first explored the region by boat in 1869. When his expedition reached Redwall Cavern in Marble Canyon at Mile 31 on August 8, the intrepid one-armed explorer wrote: "The water sweeps rapidly in this elbow of the river, and has cut its way under the rock, excavating a vast half-circular chamber, which, if utilized for a theater, would give sitting to 50,000 people."

A mechanical engineer by trade, George Bain calculates that only "650 people, without the stage and the band, would fit in Redwall Cavern." But Redwall Cavern is no less sublime and remains a must stop for modern river runners of the Grand Canyon. Once there, some outfitters play a version of "Blind Man's Bluff," whereby each person stumbles toward the rear of the limestone cavern with his or her eyes closed, trying not to open them until touching its rear walls. Struck by these wandering, mummy-like silhouettes, I sat in the back of Redwall Cavern and made several slow, handheld exposures for the essay "Enduring Magic."

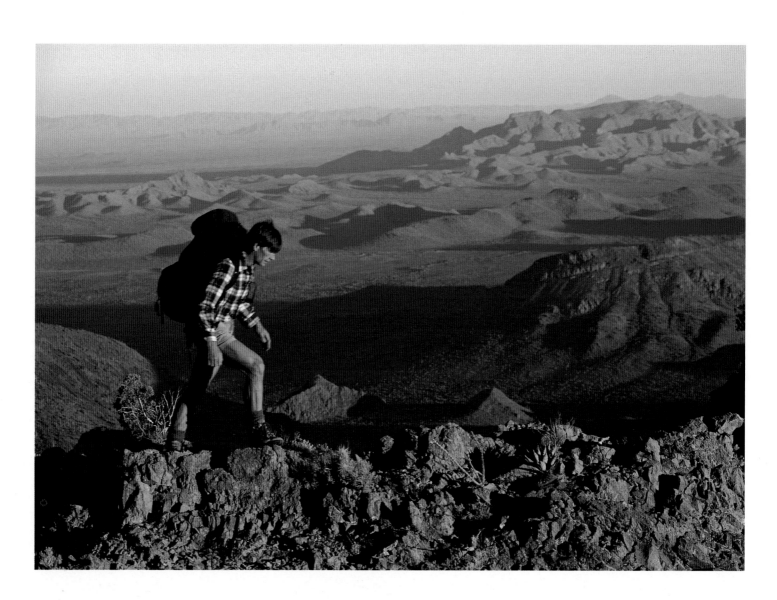

## SIERRA DEL AJO

▲

To photograph the Sierra del Ajo's 4,808-foot summit for the *Arizona Highways* book I was working on, I'd made a solo climb of the range. I took several overviews that, although striking because of the location, weren't as strong as I thought the scene could be with a person in it. I thought, as I often do when I approach "landscape photography," that people provide the viewer with a means by which to judge the sheer scale of a remote landscape—particularly one like the Ajo crest. A seventeen-mile-long desert sierra, it forms the natural boundary between the 329,199-acre Tohono O'Odham lands to the east and Organ Pipe Cactus National Monument and Cabeza Preta

National Wildlife Refuge to the west. A figure in such a vast landscape would also make the picture more personal for viewers, in that it would offer them a way to imagine themselves in such a spectacularly rugged location.

This picture, however, eluded me for several years until adventurer Randy Mulkey agreed to join me for the arduous day-long ascent to the summit of the Sierra del Ajo. Having driven several hundred miles that morning, we arrived at the foot of the mountain in the early afternoon; consequently, we didn't reach the Ajo crest until late afternoon. While looking for a bivouac site, I took this photo of Randy skirting the crest of this magnificent desert range; the sprawling desert lands of Tohono O'Odham serve as the backdrop.

## EAGLETAILS

▶

Historically located in a 10,000-square-mile despoblado of the western Sonoran desert, the 3,300-foot Eagletail Mountains were bypassed by the same Spanish explorers, mountain men and immigrant trails that avoided the austere Kofa Mountains farther west. One of the first non-Indians to explore this lost range was hydrologist Clyde P. Ross. In 1922 he wrote: "The range takes its name from a similar but higher peak...whose summit is broken into three points and has a fancied resemblance to an eagle's tail sticking straight up in the air...This peak is reported to have been scaled, truly a worthwhile bit of climbing."

While shooting "Summit Classics" for *Arizona Highways* magazine, I photographed our ascent of North Feather, the Eagletails' highest summit. But I was more excited about the photos I took of one of our party members standing atop slightly lower South Feather. When I viewed these transparencies on the light table, however, the air quality seemed poor and the light not ideal—I'd been forced to take the photo before the light had peaked, so we could get off the mountain safely before dark. A sometimes ruthless editor of my own work, I trashed all the photos, except for one I included with my submission—strictly as a record of our ascent. To my surprise, that photo ran as the double-truck opener for the story, but I knew a better picture could be taken.

Climber Doug Kasian saw the published photo and wrote requesting directions to the Eagletail's highest summit; the Canadian-born mountaineer had embarked on an ambitious four-year odyssey to identify and climb Arizona's 193 mountain ranges, and the Eagletails were on his hit list. So we struck a bargain: I would lead the former geologist up the North Feather, if he would stand atop the South Feather for my picture. On November 18, 1989, one month before he climbed his 193rd range—and became what is believed to be the first man to climb the highest points of all Arizona's mountain ranges—I took this photo of Doug Kasian.

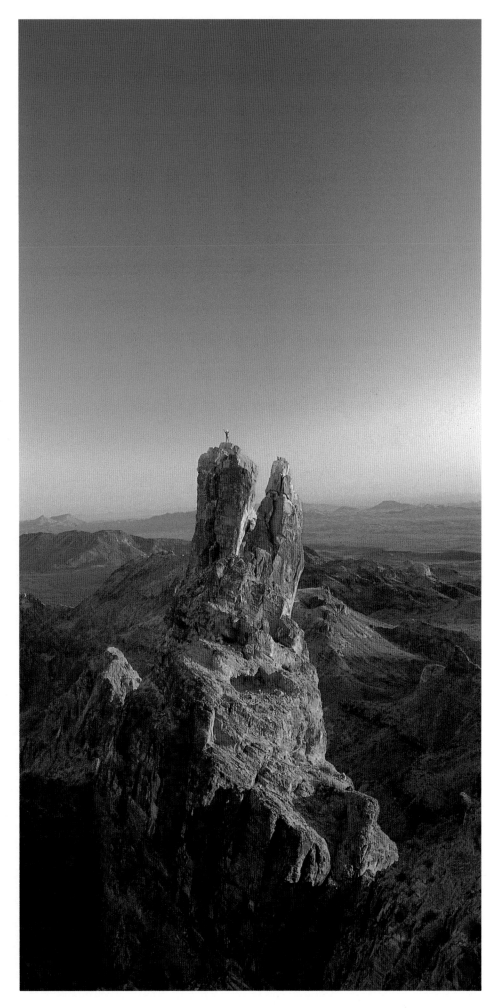

## Spirit World of the Seri Indians

▶

In "Living on the Edge," in *Native Peoples,* Jim Hills wrote that the Seri Indians envision "the world as a place where opposing forces must co-exist. In their world one can be travelling forward and yet not travelling; changing and staying the same. Where dreams and songs are intrinsically linked to physical reality, but most important, where what one intuitively senses may mean more than the obvious, what one believes to be true is, after all, the surest way."

While visiting the northern Seri village of Desemboque with Jim, I wanted to take a picture, if possible, that captured the dual world of the Seri: the real world that *cocsars,* outsiders, like us entered, and the spirit world of Hant Cai who "created all land and its features." We'd been camped in the hot, beachside dunes for three days, trying to keep the irritating gnat-like bugs called jejenes out of our eyes, ears and mouths. The sun was going down, and we expected another group of Seri would be visiting our camp to sell their exquisite ironwood carvings and baskets to Jim. So I set up my tripod, and as this group walked into camp at twilight, I took a slow exposure of what to me resembled a spirit world.

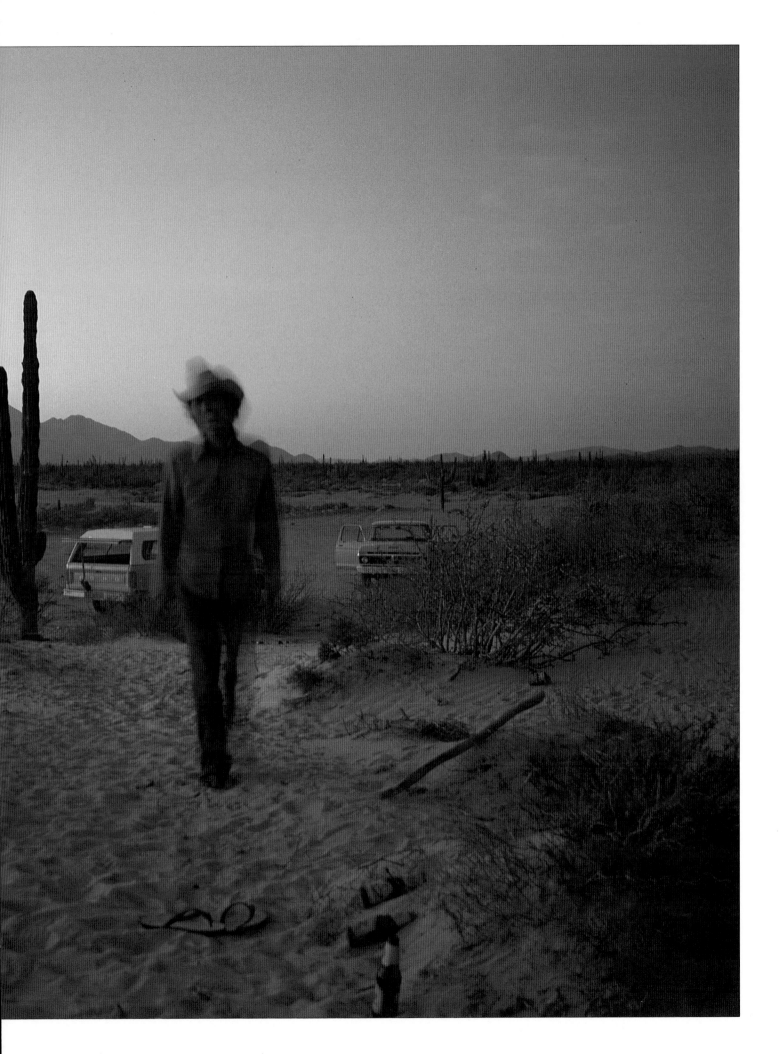

## BUCKSKIN GULCH

▶

According to an article in the 1881 bulletin, *United Service: A Military Review of Military and Naval Affairs,* an eleven-man expedition was assigned to explore the "rim of the Great Basin of Southern Utah, thence go to the Colorado River, ascend and explore the canyon of Paria, and return." What strategic importance Paria Canyon held was not spelled out. Nonetheless, the expedition pushed on, struggling through freezing water, quicksand and "caverns dark as night." On Day 3, the expedition met with disaster in a deep pool of water near the confluence of Paria Canyon and its tributary of Buckskin Gulch.

According to the report, on November 22 "…Kittleman, though shivering with cold and scarcely more than half conscious…[said] that he was not afraid to ride his horse where any other man was willing to go. The animal had entered the pool without hesitation, and had gotten nearly half-way across when, as if sucked down, man and horse disappeared. In about twenty seconds the man's head again came to the surface, as well as that of the horse, Kittleman no longer on the horse…his gaze vacant. After a few seconds, to our horror, man and horse disappeared…" Kittleman was heroically retrieved from the ice-covered pool, but all efforts to revive him failed; despondent expedition members stuffed his body into a crack before heading out of Paria Canyon for good. Had they negotiated this deathtrap, they would have no doubt been one of the first groups of non-Indians to explore Buckskin Gulch's own "caverns dark as night," as this canyoneer is pictured doing, a few miles upstream from that terrible drowning.

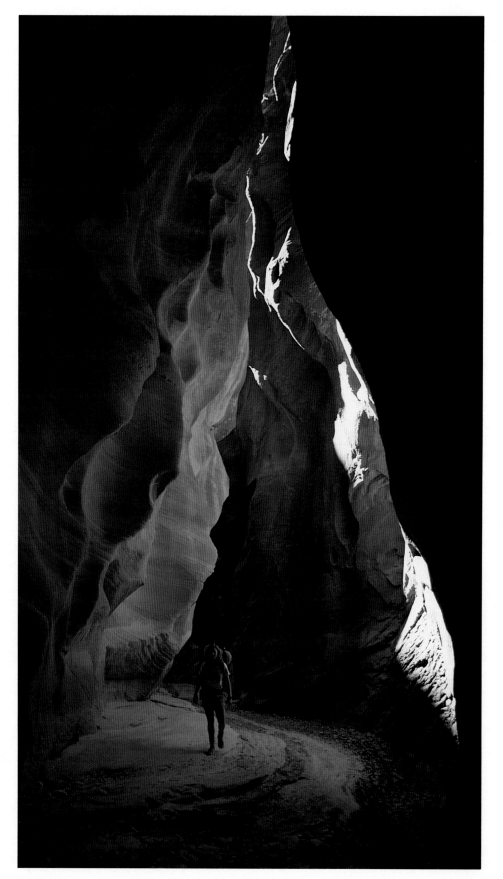

## CROSSING EL DESIERTO PINTADO

▼

During his epic 1885 cross-country walk, adventurer Charles F. Lummis chased a deer somewhere in the Painted Desert. A ledge gave way and Lummis, en route to his job as editor for the fledgling Los Angeles *Times,* fell twenty feet and suffered a severe compound fracture of his arm. After treating the ragged wound, Lummis walked 53 miles in thirty hours, reaching Winslow before he found help.

In his book *Tramp Across the Continent,* Lummis described his tortuous, life-saving trek across El Desierto Pintado: "Cut and bruised from head to foot; that agonizing arm quivering to the jar of every footstep; weak with pain and loss of blood, with cold, wet feet slipping in the muddy snow—a thousand years could not drown the memory of that bitter 6th of January." But time did erase those painful memories when, years later, Lummis wrote of another walk he took through the Painted Desert, which he described as "the most enchanted wood-pile one ever walked on."

I crossed a large tract of El Desierto Pintado with a friend in hopes of capturing that enchantment in pictures. This photo, I think, says it best.

## BOY AND BICYCLE

◄

I asked this Seri lad if I could take his picture. Without saying a word, he dropped his bicycle on the ground and lay in the dirt—daring me to take his picture.

## THE LAST FRONTIER

►

When I set out to run 750 miles from Mexico to Utah, I viewed the land as the "last frontier." Largely unchanged since fleet-footed Indians first ran across it a millennium ago, much of Arizona remains the most diverse, rugged and beautiful terrain on earth.

From my notes of Day 32, Wednesday, May 20, the day before I finally crossed into Utah: "The wind is at my back...movement is effortless; there is no strain. I am gliding beneath the eastern escarpment of the Kaibab Plateau, and I don't have a care in the world. For the first time on the entire route, I can visually see all the ground I will run today and most of what I will run tomorrow.

"In Carobeth Laird's eloquent ethnography, *The Chemehuevi,* she wrote: 'No more moccasin feet tread silently upon hard-packed trails whispering *tcawa, tcawa, tcawa*...a whole mode of perception is lost, forgotten, never to be regained. Even if the remaining native people increased and prospered, their thought has so departed from the old ways, that there would be no eyes to see desert, mountains, and River [Colorado] as they once were seen.'

"Unfortunately, Laird is right. But for a few elusive hours, my running, my breathing, my senses all come together and it feels as though I can run forever; it's then, I believe—when I am simply motion—that I've transcended time and am seeing this magnificent land as it once was seen by those who ran before me. That, I tell myself, I will try to hold forever. But the vision is only fleeting, something that cannot be held anymore than I can hold quicksilver in my palm: it is always changing, continually taking on the form of the land as my feet and mind momentarily mold themselves to it."

Of the many pictures I took during that adventure, this is the one photo, I felt, that best captured the changing form of the land and how my running and impressions responded to it.

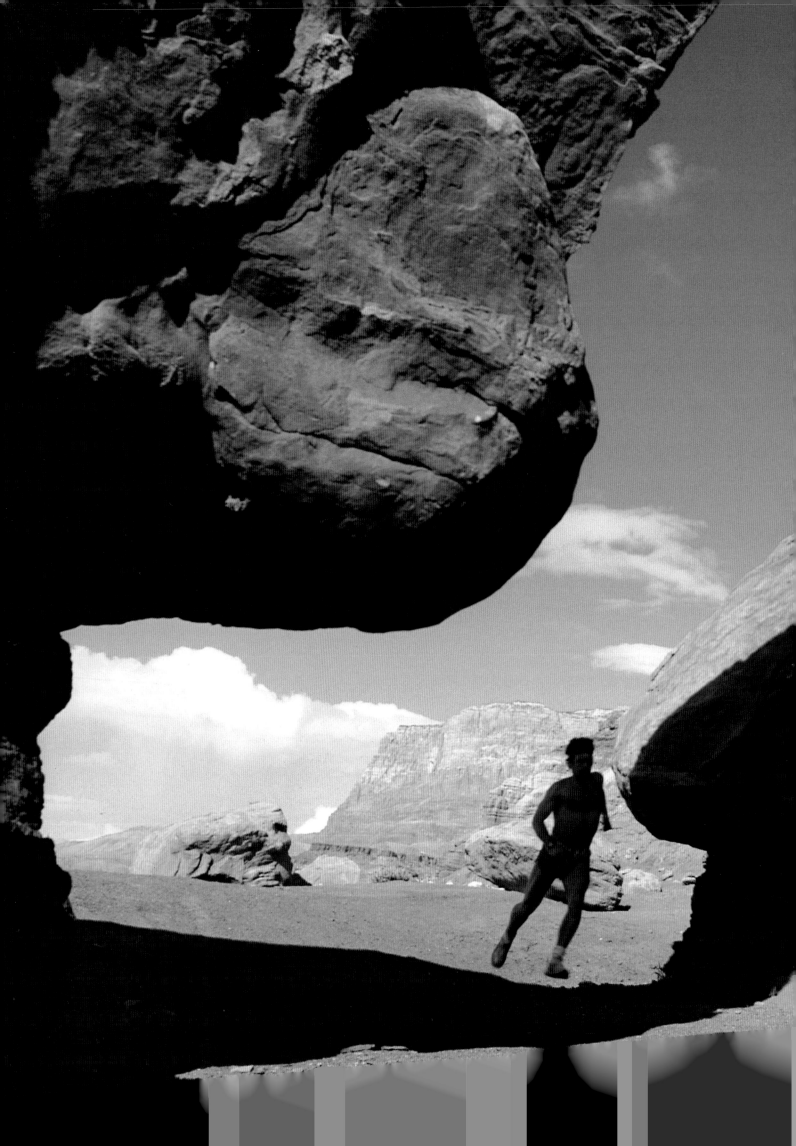

# WORK

▼▼▼▼▼▼▼▼▼▼▼▼▼

## MOTHER LODE COUNTRY

▶

*More than a century after the California gold rush of 1849, a second gold rush began after December 31, 1974; that date signified the end of the forty-one-year-old legislative ban on Americans owning gold bullion in the United States. As a result, prices surged on the world gold market and hordes of modern-day "forty-niners" took to the hills with picks and shovels, gold pans, portable dredges and underwater diving gear. Most began their fevered search for pay dirt exactly where the original forty-niners left off: on the western slopes of California's Sierra Nevada Mountains, along State Highway 49, in what was once known as Mother Lode Country (due to the extremely high concentration of the precious metal). It's been estimated that fifty to seventy-five percent of the gold was overlooked during the first Gold Rush, and with gold futures commanding more than $400 per troy ounce, it made perfect sense for these modern gold seekers to prospect the same "diggings," gloryholes, rivers and gravel bars.*

On assignment for *Life,* I spent four days on the South Fork of the Stanislaus River shooting a picture essay of modern gold seekers along a privately-owned stretch of what was the Río de Estanislao of Mexican prospectors. For reasons never fully explained, the story was killed; but then, that was always a possibility with *Life,* that a breaking news story set aside other pieces, especially after the magazine went monthly. The "Mother Lode" story was quickly picked up by a national airline magazine, but received even greater play when the Milan-based agency Marka distributed it to an Italian adventure magazine, *Jonathan,* which ran twenty-seven pictures.

Of those photos, one stands out as a favorite: the detail of New Yorker Nicholas Meier holding gold nuggets in his teeth. Using a four-foot-long, jerry-rigged snorkel, long breaths of air, and an old screw driver, Meier pried his share of the Mother Lode out of a crevice in a deep pool of water.

## OUTWARD BOUND INSTRUCTOR

▼

In 1986, 30-year-old Priscilla "Cilla" Mc-Clung was one of several hundred instructors responsible for leading some 14,000 people through Outward Bound's mentally and physically challenging wilderness training that year. Having taught outdoor education for a decade, it was a joy to photograph this seasoned outdoorswoman in action. But what was particularly impressive about Cilla was the way she deftly shattered the stereotype of a woman instructor as she, with assistant Joey Kenig, led a contingent of mostly male executives—including the president of Outward Bound—on a week-long canoe expedition through the canyons of the Rio Grande.

Preparing her canoe for the arduous portage we were about to make through a huge boulder slide in Santa Elena Canyon, Cilla McClung took little notice that most men she led could only dream of doing what she does.

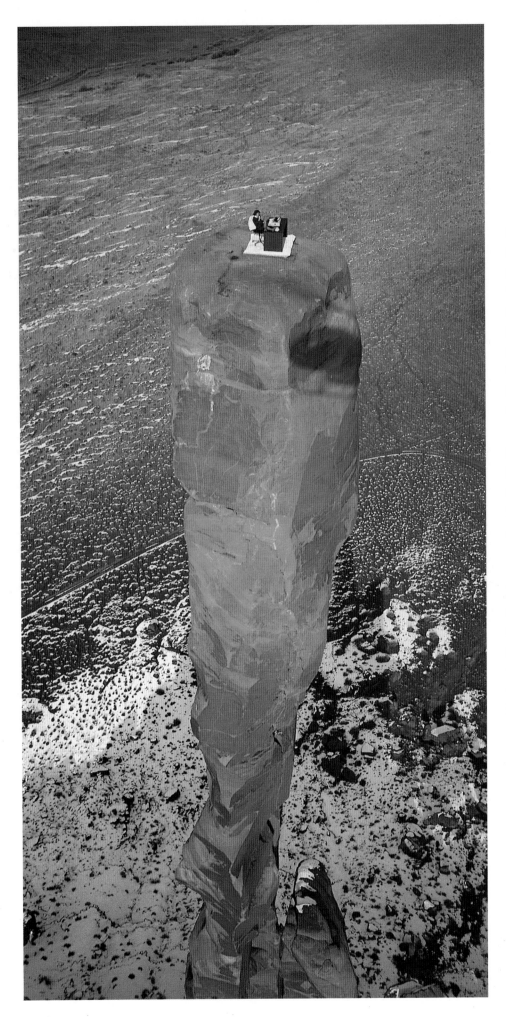

## THE TOTEM POLE

◀

You've seen car commercials where someone put an automobile atop what looks like an unscalable summit? A helicopter put it there, of course—with the help of several hungry "climbers." Some ad men had an even better idea for an IBM commercial: put a 250-pound executive desk, a huge typewriter, and a "secretary" atop the Totem Pole in Monument Valley, Arizona, and armies of secretaries will be beating down the doors to buy the typewriter. Right?

There were only two glitches to this art director's brainstorm: it was the dead of winter in the 5,000-foot-elevation Great Basin Desert, and the 600-foot-high Totem Pole is only fourteen feet in diameter—not quite big enough to land a helicopter.

Enter two hungry climbers.

"Fourteen feet across? Sure, no problem," Dave Ganci and I said when we first met Independent Artists producer Paul Rosen to view an under-exposed, out-of-focus Polaroid snapshot of the tiny summit. At the time, however, the two of us had our feet firmly planted in the thick, warm carpet of Film Producers Warehouse in Phoenix, while a satchel full of $500 Barclay's traveler's checks sat on the table. Naturally, we said "Sure, no problem." But the cold reality of our decision would smack us squarely in the face the moment we jumped out of the "mother ship," a Lama Alouette Helicopter, onto the slippery, snow-covered summit of the Totem Pole twenty-four hours later. There, with assistant Richard Nebeker, we tried to survive the three winter storms that swept through Monument Valley during the five-day shoot—at least long enough to collect our share of $500 Barclay's and watch the thirty-second spot air during the "Winds of War" television mini-series.

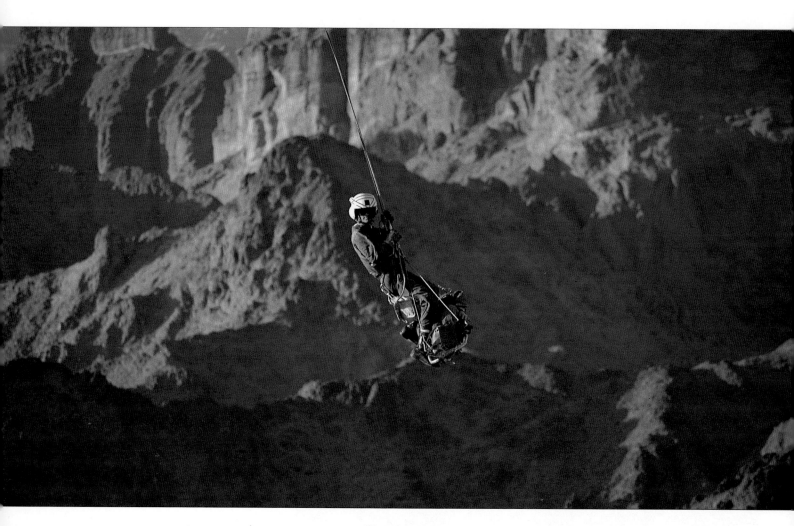

## SKYHOOK

▲

When adventurers get in way over their heads, they sometimes talk about getting a "skyhook" to pull them out of that dicey predicament. Most, however, don't know about Rescue-1; when it comes to hairy rescues, they own the sky—hook, line and savior.

To continually hone their expertise for saving downed aviators—and, not surprisingly, a large number of civilians—Rescue-1 frequently practices Short-haul Rescue scenarios. For instance, when victims are extracted from mountainous ledges, more often than not they've got to be hauled to a level landing zone before they can be loaded into the chopper. During this phase of the emergency flight,

Rescue-1 generally cruises at 40 knots, fifty to 200 feet off the deck. However, when recovering a victim from dangerously rugged terrain, would-be rescuers are forced to fly much higher in order to safely avoid hazardous winds and topography en route to the nearest suitable landing zone.

While photographing Naval Corpsman Noel Ramirez flying in front of 2,100-foot Picacho Peak in California's Chocolate Mountains mid-maneuver, I wasn't sure what would be more frightening: riding the litter as Ramirez was, 1,500 feet off the deck, or being the victim staring up at the chopper a hundred feet overhead, wondering when the rope was going to break.

## CHOPPERTOWN

◄

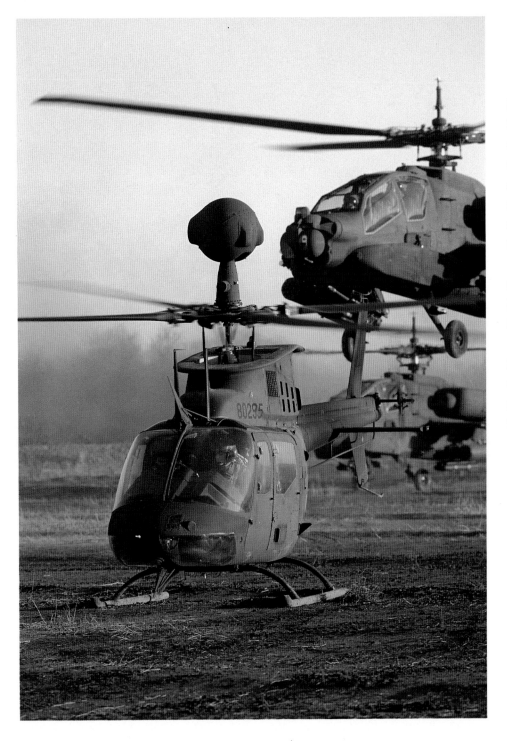

On the set of *Wings of the Apache,* Arizona. Playing an Army Scout helicopter pilot named Billie, actress Sean Young was swooned over by cast, crew and military personnel alike. Here, somewhere in the "Catamarca Desert, South America," with the Drug Enforcement Administration and the Apache Task Force Mission, Sean Young (lead ship, right side) receives technical advice from a real Army Scout pilot.

One of the many things that intrigued me about this movie set was the profusion of Army helicopters and pilots hired—and it was no more evident than in this scene.

What struck me about this particular photo, however, was the dangerous tension created by the whirling blades of the Scout in the foreground and the Apache attack helicopters in the middle and background.

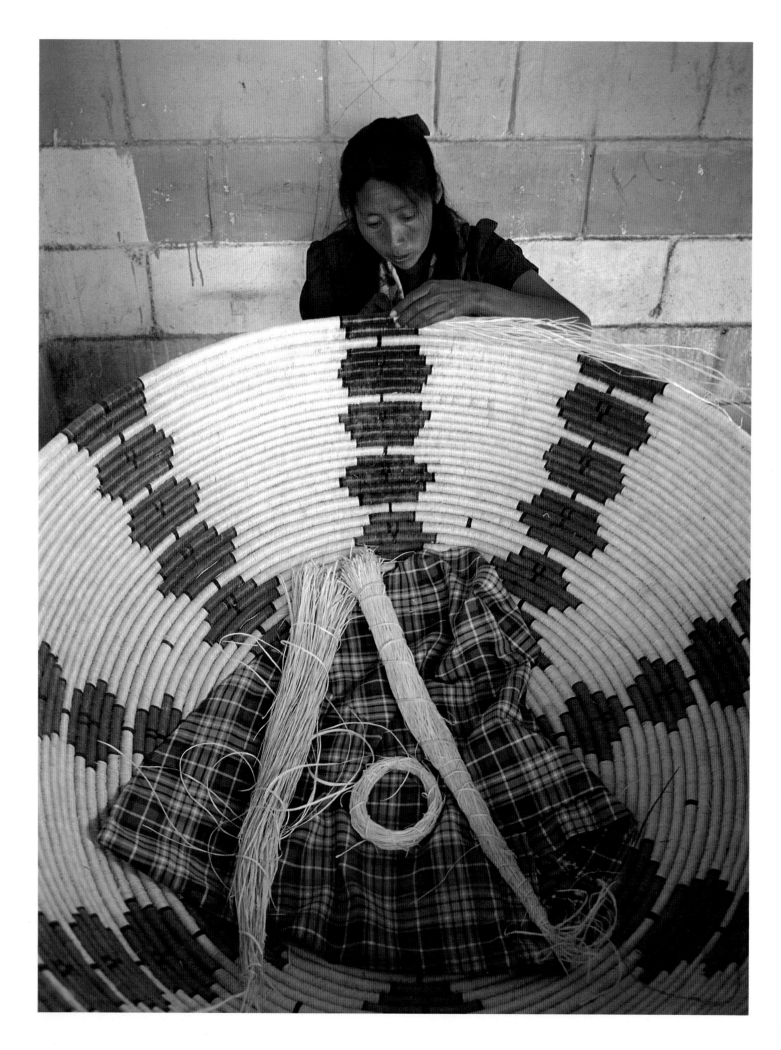

## BASKET WEAVER

◀

A well-known Seri basket weaver, Rosa Amalia Barnet, weaves a *sapim* basket with dried torote and a dagger-sharp deer bone awl. Baskets such as these contribute to the Seri Indians' vital arts and crafts market, which supplements their sea-based economy of commercial fishing.

They say that when a Seri women pulls the damp torote fibers through the finger-tight coils of her basket, she can hear it sing, perhaps because she sings while collecting dried torote from the rattlesnake-infested desert of Seriland. This basket sang for me, and since I couldn't buy it, I at least wanted to show the scale and its exquisite design before its completion several months hence. Rather than photograph Rosa from the side, I asked her if she would allow me to photograph the basket from the inside out. She said yes, and went about her weaving.

## BOOTS

▼

In *Pictures Under Discussion,* John Loengard wrote: "Hands photograph well because they are what they are. We don't put them on diets. We don't inject silicone into our thumbs to make them prettier. Like feet, they lose their baby fat and take on character early. They are always on my shopping list when I do a story." Loengard's photo of artist Georgia O'Keeffe displaying, in her white palm, the smooth black stone she "stole" from Eliot Porter is a work of art. Conversely, Loengard's picture of cowboy Whistle Mills' chipped, cracked and calloused left hand is a remarkable detail photo, because it comes close to being a single-picture photo essay, as well. In the background, we see what the reins and lariat, clasped in Mills' range-worn hands, are used for: the herd of horses he's rounding up.

Most of the work I did to pay my way through high school and college was done with my hands—and my feet—whether I was picking cantaloupes with migrant workers, digging trenches on a fire line, building theater sets, or rock climbing. Consequently, both hands and feet have always fascinated me as a photographic subject.

Roughstock riders, for instance, not only rely on a single hand to hang onto a bull, or bareback or saddle bronc, but also they're scored by how well they use their feet during the ride. To keep their boots from flying off while "marking out" the animal with their spurs, roughstock riders cinch on their boots with ankle belts, or leather rawhide straps—as this cowboy has.

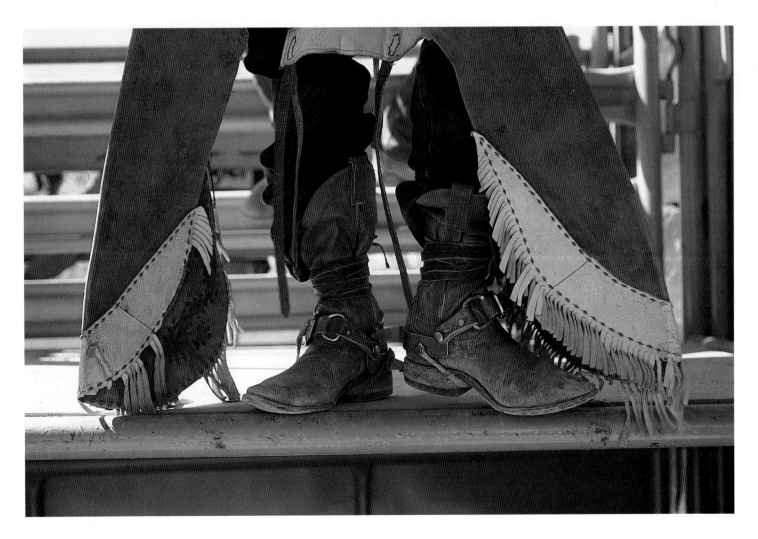

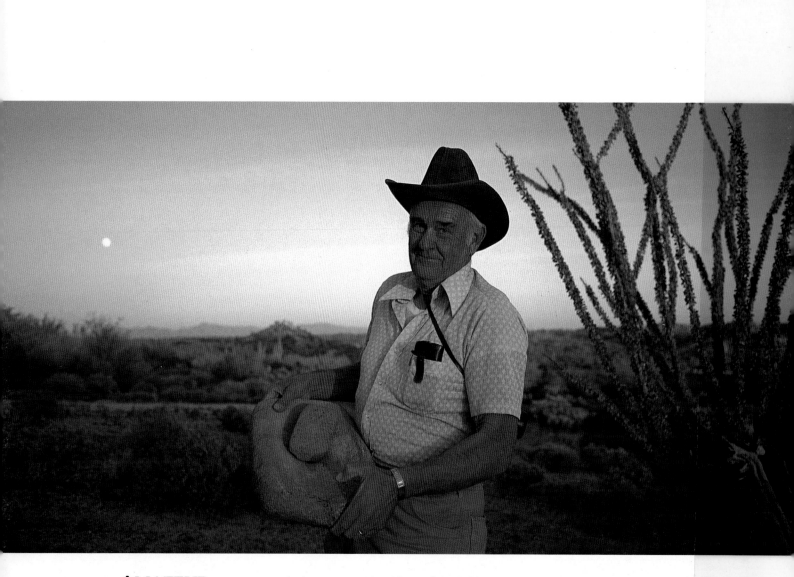

## AMATEUR ARCHAEOLOGIST

▲

Not everyone risks his hide for gold, prize money, or Barclay's traveler's checks; for some, like amateur archaeologist Lu Hagler, their work is simply a labor of love. Pictured here, Hagler proudly holds a *matate* he unearthed while helping excavate an ancient Hohokam site in the central Sonoran desert.

## THE LAST GOODBYE

▶

Death is the ultimate toll risk exacts. We try to avoid it at every turn, but it always rears its terrible head when we're least prepared for it. Those who purposely seek out or face risk,

then, are considered "crazy." And, if for some reason they die while engaged in such an activity, society often looks upon them with a condescending, "He should have known better." Yet, if you look at the actuarial statistics of deaths attributed to high-risk activities like rock climbing, sky diving, scuba diving, etc., they pale in comparison to those of people who stay home and indulge in "safe" activities like overeating, watching television and dying of heart disease—as some 690,000 insured people do each year. As a nation of automobile lovers, on the other hand, we're also blind to, or accept, the grim fact that 65,804 people are slain on our highways each year. So while the sky diver thinks it's normal to jump out of a "perfectly good airplane," most think it's less risky to go back for a second helping and pop another cassette in the VCR, or drive a car head on toward another at 55 miles per hour.

During a break in filming of *Wings of the Apache,* I was thinking about the broad spectrum of risks faced by the cast, crew and pilots—and the ramifications of making the slightest error, however "safe" or "risky." Troupes of extras were marching through the Catamarca Desert, and the setting sun was blazing through a shroud of dust. I focused my camera on the scene, and at that moment a "soldier" waved goodbye to another.

At the time, the photo meant the end of the shoot for me. But when I look at the picture now, it means something else. As long as we can find the balance between the two extremes of risk—wherever we face it, and in whatever form it takes—we can prolong facing our own "last goodbye" until the last possible moment. Some, like me, now look forward to calling it a ripe old age.

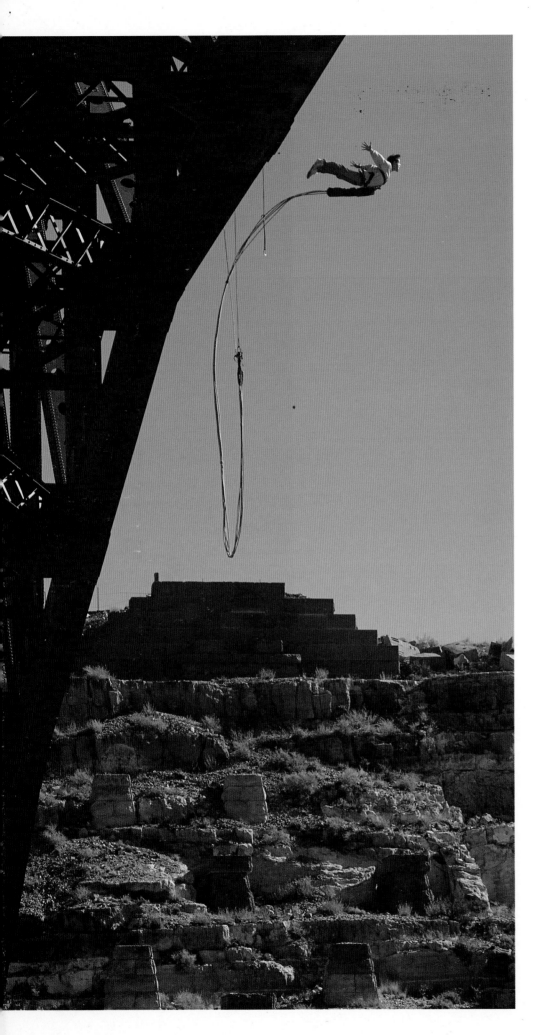

## THANKS TO...

Most of the images in this book would not have been possible without the picture editors and other trusting souls who first took a chance on an unknown photographer from the boondocks of Arizona; ultimately, it was those pivotal breaks that launched my career and honed my vision, and for that I can't be grateful enough. I'd like to thank Jennifer Coley of the New York office of Gamma-Liaison; Peter Howe and Barbara Baker-Burrows at *Life;* John Loengard; Bryant Gumbel at the Today Show; Guy Cooper at *Newsweek;* Kathy Ryan at *New York Times Magazine;* Howard Chapnick at the Black Star agency; Hazel Hammond and Bob Ciano at *Travel & Leisure;* Elvira Mendoza at *Geomundo;* Bernard Newman at *Mountain;* Ursula Olmini and Antonio Ernazza at Marka in Milano; Jim Cohee at Sierra Club Books; Bob Farrell, Wes Holden and Pete Ensenberger at *Arizona Highways.* I'd also like to thank Rob Elliott at Arizona Raft Adventures; Amelia Hernandez and Jim Hills at *Native & Nature;* Tom Thompson, Don Dedera and Gary Avey. Last but not least, I'd like to thank the compadres who accompanied me on some of these adventures; Mark Thompson at American & World Geographic Publishing for making this book possible; Barbara Fifer for her insightful editing and David McKay for his book design; and photojournalist Christine Keith for first opening my eyes to the enduring power of the still image.

## ABOUT THE AUTHOR

John Annerino is a photojournalist whose work has been published in *Life, Newsweek, New York Times Magazine, Outside,* and *Travel & Leisure,* among many others; he is represented by the Gamma-Liaison picture agency in New York and Paris and the Marka agency in Milano. Author and photographer of five books, Annerino lives in Tucson, Arizona.